The Fantasy Illustrator's
Technique Book

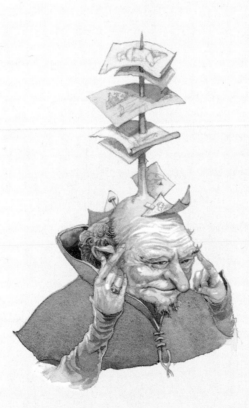

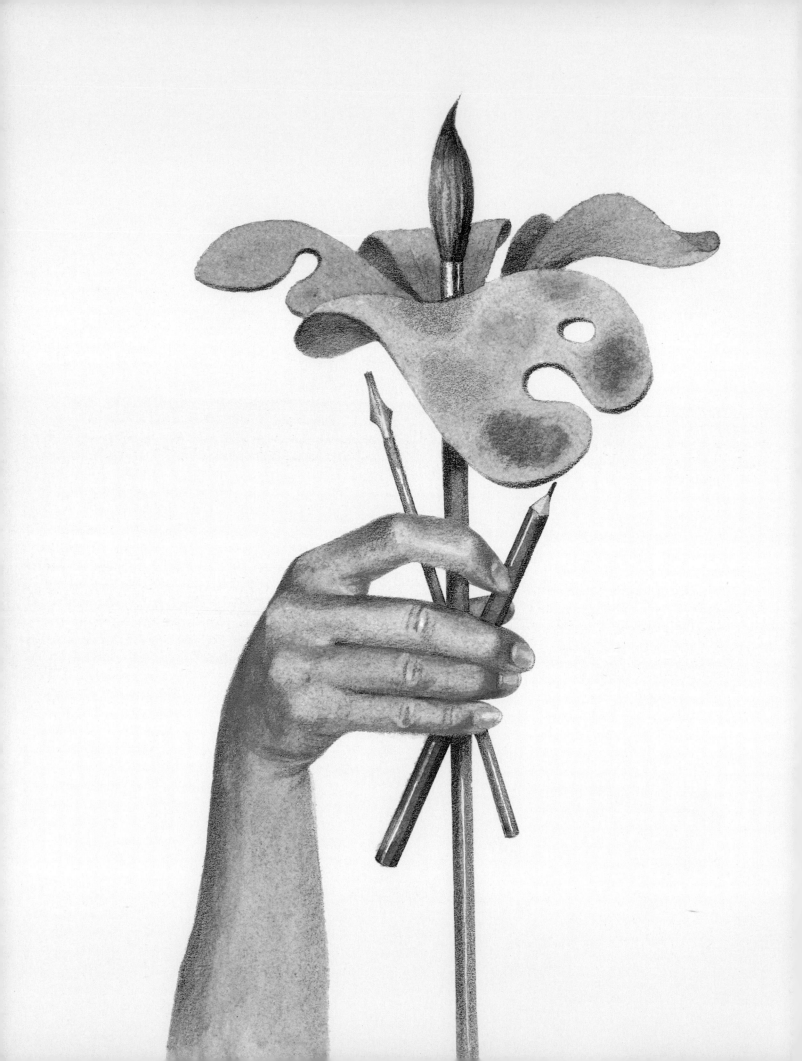

The Fantasy Illustrator's
Technique Book

From creating characters to selling your work,
learn the skills of the professional fantasy artist

Gary A. Lippincott

BARRON'S

A QUARTO BOOK

First edition for North America
published in 2007 by Barron's
Educational Series, Inc.

All inquiries should be addressed to:
Barron's Educational Series, Inc.
250 Wireless Boulevard
Hauppauge, New York 11788
www.barronseduc.com

ISBN-13: 978–0–7641–3574–3
ISBN-10: 0–7641–3574–0

Library of Congress Catalog Card No.
2006920392

Conceived, designed, and produced by
Quarto Publishing plc
The Old Brewery
6 Blundell Street
London
N7 9BH

QUAR.TFI

Senior editor: Liz Pasfield
Art editors: Natasha Montgomery,
 Michelle Stamp
Assistant art director: Penny Cobb
Copy editors: Bridget Jones,
 Hazel Harrison
Designer: Tanya Devonshire-Jones
Additional artwork: Sally Launder
Additional text: Paul Barnett
Picture Research: Claudia Tate

Art director: Moira Clinch
Publisher: Paul Carslake

Manufactured by Provision (PTE) Ltd,
Singapore
Printed by Star Standard Industries
(PTE) Ltd, Singapore

9 8 7 6 5 4 3 2 1

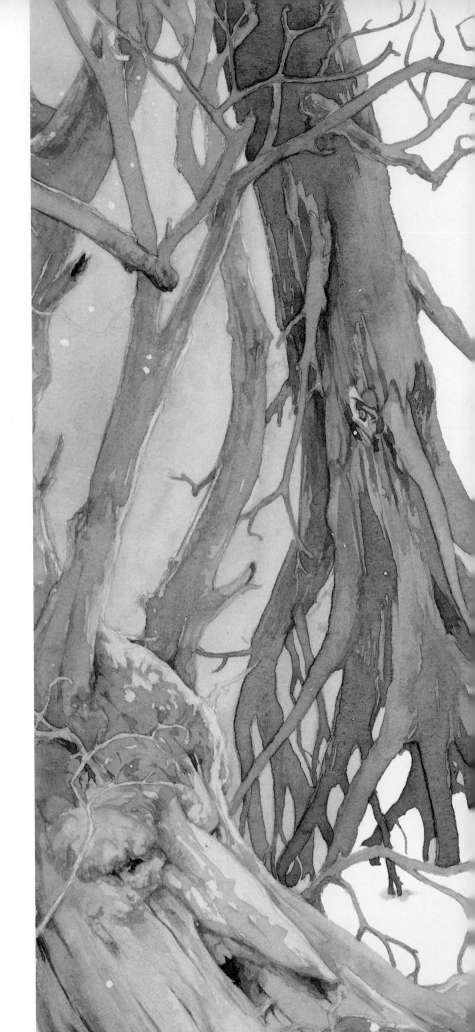

Contents

Introduction

Fairies, wizards, and sorcerers; mythological beasts, denizens of magical places; and a host of other enchanted subjects are not available as models from whom the artist can draw or paint. How easy it would be for the fantasy artist to have that unicorn pose very still, next to the troll, with the fairy flitting about its head. Being able to ask a dragon to crawl out from its lair, and spread its incredible wings to the sky, would allow the artist to sketch, make notes on color and form, take a few photographs for future reference, and this would be the ideal way to get everything just right. Unfortunately, the fantasy artist doesn't get the chance (or very rarely) to set up scenes. Everything may be clear in the mind, with no doubts about how things should look; but, without models, making a convincing piece of art that depicts the scene in a lifelike way becomes difficult.

How does the artist draw from the imagination in such a way that the fantasy subject is expressed convincingly? This book provides clues to how works of art are created without access to the visual models that normally make drawing real-life subjects so much easier. Turning a mental vision into a two-dimensional work of art—that is, trying to give the illusion of a three-dimensional subject—is the task for the fantasy illustrator.

The techniques explained in this book are neither groundbreaking nor unique, but they highlight the fact that it is how the fantasy art is developed that makes it convincingly real (or not). By using certain simple steps to create subjects that cannot be copied from life, the artist's drawing skills and ability to analyze the subjects will be enhanced. For example, the shapes, anatomy, and proportions can be studied no matter what the subject. This book pays attention to learning how to plan the artwork, from designing the overall picture to positioning the details. The general theme is learning to "build" the art, one simple step at a time, taking it slowly.

It would take an author many years to write a comprehensive book on every topic that could be discussed on the subject of producing fantasy art, and the book would be huge, weigh a tremendous amount, and itself resemble an item from a work of fantasy art. The following chapters attempt to outline the most basic steps to producing this kind of art in the hope that the artist, and reader, will have the ability to let imagination go wherever necessary to produce works of magic and enchantment.

GARY A. LIPPINCOTT

INTRODUCTION

setting up a
Workspace

The type of art you do dictates the type of equipment you need. Commercial artists, unlike fine artists, work to meet other people's needs and deadlines. Their work space and equipment must enable them to do their work as efficiently as possible. It doesn't have to be expensive, but it must be comfortable and appropriate for the job.

The studio

The first requirement is a place to work. You don't really need a dedicated studio space, but you must feel comfortable and be able to concentrate without unnecessary distractions from others.

If you have a spare room with good natural light, so much the better, as lighting is vital if you are working in color. Poor light not only is bad for your eyes but it also affects your perception of the colors you are using. You notice this if you complete a painting in standard electric light, which has a yellowish cast, and then look at it again in daylight.

Daylight is always best, but of course the amount of daylight you get is not guaranteed. If you live in the Northern Hemisphere, a large north-facing window is ideal because you will get no direct sunlight and thus little change through the course of the day. But don't worry if you don't have this luxury, because any window is better than none. If you are working in a sunny room and find changes in the light distracting, you could consider putting up a translucent white blind, which will diffuse the light, making it more even. A white sheet would make a less expensive alternative. If possible, position your table so that your hand does not throw a shadow, which can make it difficult to see what you are doing.

Additional lighting

If you don't have good natural light, or want to work in the evenings, you will need a good light over your work table. Adjustable-neck lamps are ideal because they can be changed to different heights and angles. Daylight bulbs are available from most art stores in different wattages. They have a blue coloring to the glass to balance out the light color, and although they are more expensive than standard bulbs, they last a long time. Low-voltage halogen lights come a close second because they have a very bright white light. Halogen lamps also have the advantage of being small and lightweight, so you can hang them from a hook on a wall quite easily.

Boards, tables, and chairs

The working surface you choose depends very much on how large you want to work. Most artists use a drawing board of some kind, whether a ready-made one or a sheet of particleboard or plywood cut to the required size. Some drawing boards can be angled up from the horizontal, giving a good slope to work at as well as preventing back strain; but if you are using a homemade board you can prop it up on wooden blocks or a pile of books.

You will need a table that gives you enough room for all your drawing and painting tools, but again you don't have to buy one unless you are setting up a more permanent workspace. The family dining table is perfectly adequate, but cover it with a sheet of plastic first. Many inexpensive tables are available, or you can make your own from a large sheet of particleboard and some trestles.

More or less any seat will do as long as it's comfortable, but an adjustable chair is better, especially for those with potential back problems. But whatever chair you use, the chances are that you will spend too long hunched over your work, so always stand up regularly.

Storage

As you accumulate equipment over the years, storage can become important. A good set of drawers will enable you to keep all your pencils, crayons, paints, erasers, knives, and rulers tidy, but you can improvise by using cardboard or plastic boxes to start with.

Some artists keep all their paper and boards, as well as finished artwork, in a chest of drawers called a flat file, which can be expensive. It's a lot more practical to keep one or two rigid portfolios propped against your wall to hold large sheets of paper and finished work.

9

Tools and Materials

⟐

To create the paintings and drawings shown in this book or to produce your personal versions of them, you will need a selection of the tools and materials shown here and on the following pages. Don't worry if you have your own favorites or can't afford expensive equipment; use whatever is handy. Some of the images have been produced digitally, but, again, don't worry if you don't have the software, because all of them can be drawn and painted by traditional methods.

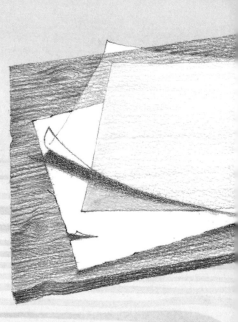

Paper

For making pencil drawings and rough sketches to try out ideas, use ordinary smooth white drawing paper; but if you want to work in color you will need a selection of papers tailored to your chosen medium.

Drawing paper

Ideal for pencil drawings and pen-and-ink work, but choose a good quality. Photocopy paper is an inexpensive alternative for trying out ideas.

Layout paper

Much thinner than drawing paper, and partially translucent, so it is good for refining drawings over several stages rather than repeatedly erasing the same drawing.

Illustration board

Used as a surface for creating artwork that will be scanned or reproduced onto other mediums. It has as many various textures as watercolor paper, so choose the surface to suit your requirements.

Pastel paper

Made especially for pastel drawings, it has enough texture to hold the powdery pigment in place. It is produced in a range of colors and can also be used for colored pencil drawings.

Tracing paper

Useful for accurate tracing from photographs or other reference, and essential for light box methods. However, pencil lines can smudge easily.

Blotting paper

Placed under your drawing hand, this prevents grease and moisture from getting onto the drawing. It is also useful for removing excess paint.

Smooth (hot-pressed) watercolor paper

Can be used for most drawings and paintings, including colored pencil and acrylic, but not suitable for wet watercolor washes or pastel work.

Medium surface (cold-pressed) watercolor paper

More heavily textured than hot-pressed paper, and the most popular choice for watercolor work or pen and wash.

STRETCHING PAPER

Watercolor paper is made in different weights, or thicknesses, and you must stretch the lighter ones before using them or they will buckle when you apply the wet paint. Stretching your paper before painting will give you a smooth flat surface to work on. This surface will stay flat as you work, and the finished painting will dry flat. Stretching isn't difficult, and it means that you can economize by buying lightweight paper. If you can fold the paper easily, it should be stretched.

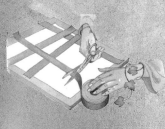

1 Cut four strips of gummed paper tape to the required length (to cover the edges of the paper) before wetting either it or the paper.

2 Wet the paper on both sides with a sponge, or soak it briefly in a basin or bath.

3 Wet the gummed side of the tape; then turn it over and stick it all around the edges of the paper, smoothing it with the sponge. Let it dry naturally.

Drawing media

The first requirement for any artist is a good range of pencils. You can also draw with inks (see page 12), and colored pencils.

Pencils and erasers

Pencils are made in different grades, H denoting soft and B standing for black. There are several different types of erasers, but avoid very hard ones because they leave greasy smears and can damage the surface of the paper.

Grades of pencil

HB is in the middle of the range, and is a good all-arounder; 2B, 4B, and below are better for sketchy or expressive work.

Mechanical pencil

A useful alternative to wood-cased pencils because you can change the lead to suit your purpose.

Colored pencils

Colored pencils are popular with illustrators, especially for detailed work, but the softer ones can also be blended for broader effects. They are made in a huge range of colors but can also be bought in boxed sets of 12 or more.

Chalky colored pencils

Can be blended for soft effects by rubbing with a rolled paper stump (see below) or a clean finger.

Waxy colored pencils

Excellent for detail, but less easy to blend than chalky pencils. Both types can be mixed on the paper surface by laying one color over another.

Water-soluble colored pencils

Can be used dry, like a standard colored pencil, or spread with water to form a wash or simply to soften the lines.

Pastels and pastel pencils

Soft pastels, which crumble and smudge easily, are not well suited to detailed illustration work, and they also make a great deal of mess, requiring a dedicated work space—or a large dust sheet. Hard pastels and pastel pencils are more manageable, and good for drawing over watercolor or acrylic to define detail and create areas of texture.

Hard pastels

These are good for covering large areas such as backgrounds because they can be used on their sides.

Rolled paper stump

Sometimes called a torchon, use this implement for blending small areas of pastel or colored pencil.

Pastel pencils

Harder than the paper-wrapped pastels, but softer than colored pencils, these are easy to blend.

Eraser

A white plastic eraser is best for removing large areas of pencil. Remove debris with a soft brush before continuing with the drawing. A kneaded eraser can be pulled to a fine point to remove small areas and produce highlights.

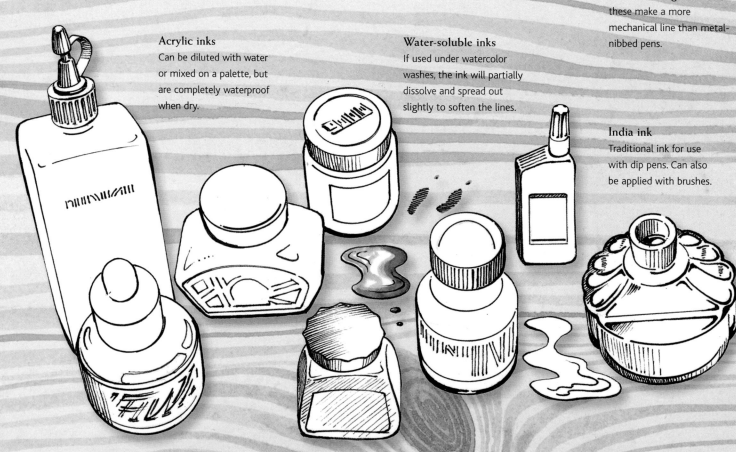

Pen and ink

Drawing with a pen allows you to build up very fine detail and has the added advantage of not smudging. Pen and ink is often combined with watercolor or acrylic washes, but both pens and inks are made in a wide range of colors, so you can complete a whole drawing with inks.

Quill (1)
A quill pen can give interesting and authentic results. Ink lines can be varied between thick and thin and by altering the pressure you apply to your strokes you can also taper your lines.

Dip pen (2)
Pen holder with interchangeable nibs, allowing you to make a variety of different lines. These pens are slow to use because they must be charged with ink after each stroke.

Fountain pen (3)
Metal-nibbed pen with ink cartridge. Delivers a constant flow of ink.

Fiber-tip pens (4)
Available in different point sizes and a range of colors, these make a more mechanical line than metal-nibbed pens.

Acrylic inks
Can be diluted with water or mixed on a palette, but are completely waterproof when dry.

Water-soluble inks
If used under watercolor washes, the ink will partially dissolve and spread out slightly to soften the lines.

India ink
Traditional ink for use with dip pens. Can also be applied with brushes.

Painting media

Your fantasy illustrations can be painted with watercolors, acrylic paints, or gouache. Experiment with the different results these types of painting methods produce and find one that enhances and suits your style.

Brush choices

There are many different ranges of brushes made for use with all types of paints and inks, and since some of them can be very expensive, it is best to start with a small range. For watercolor work three brushes in different sizes will be adequate, though you may need more for acrylic. The two main brush shapes are rounds and flats. Rounds are the most versatile, though some watercolor painters prefer flats for washes and dry-brush methods. The best watercolor brushes are sables, but there are many excellent synthetic alternatives, as well as sable and synthetic mixtures. These can also be used for both inks and acrylics as long as they are rinsed out well after use, though there are ranges of brushes designed especially for acrylic work, made from ox hair, bristle, or synthetic materials.

For fine lines such as tree twigs and grasses, you might like to try a rigger brush, so-called because it was originally used by marine artists to paint rigging. These have much longer hairs than normal brushes and can be used on their sides as well as their points. Inexpensive decorators' bristle brushes and children's paintbrushes are useful for effects such as stippling, dry brush, and some acrylic methods, while old toothbrushes are essential for watercolor and gouache spattering methods.

Rigger brushes (1)

These are ideal for painting long, straight lines, which are hard to achieve with the point of a round brush. These brushes are sometimes called "stripers."

Nylon brushes (2)

These are made specifically for acrylic work, and are tough, hard wearing, and springy.

Chinese brushes (3)

These are now becoming widely available, and because they are considerably less expensive than most watercolor brushes, are well worth trying. They can create a wide variety of different marks.

Flat brushes (4)

Flat brushes are chisel shaped and held in flat ferrules, and are good for washes and for broad lines. The long-haired brushes hold enough extra paint to make one continuous stroke across the paper.

13

TOOLS
AND
MATERIALS

Palettes

There is a large range of palettes available for watercolor, acrylic, and ink, made from either plastic or ceramic. Plastic palettes are not suitable for acrylic or acrylic ink, as any leftover color is impossible to remove. Acrylic is best mixed on disposable paper plates or a stay-wet palette.

Stacking palettes

Useful if you are short of space and only need a few mixing wells.

Ceramic palettes

A popular choice for watercolor work, as they have deep wells for mixing. They often come in the shape of a flower.

Watercolors

Watercolors are especially well suited to fantasy paintings because of their translucent quality. They are also highly versatile, and can be applied in various ways from thin, wet washes to areas of solid, brilliant color and fine linear detail.

Watercolor choices

Watercolors are made in tubes and flat pans, so the first choice to make is which to buy. Pans are designed to fit into a paintbox with a built-in palette for mixing, and are thus more convenient for outdoor work, but apart from that the choice is a personal one. If you want to use strong paint for more opaque techniques, tubes are better, as you can squeeze out the creamy paint and apply it with the minimum of dilution, while pans have to be rubbed quite hard with a wet brush to release strong color. Pans in a paintbox get dirty through the process of color mixing, requiring regular cleaning, but with tubes you can simply squeeze out small amounts of color as needed. Any that is left over on the palette at the end of a working session can be reused, as all watercolors contain gum arabic to keep them moist.

Choosing colors

You can buy paintboxes complete with pans or tubes of paint, but you do run the risk of not having the colors you need, so it is usually better to buy colors individually, starting with a fairly small range and building up gradually.

Paint boxes
Most of the ready-made paint boxes contain half-pans rather than whole pans, but even these last for quite a long time. They can be replaced when finished, as all colors can be bought individually.

Pans and half-pans
Artists who work on a large scale usually prefer to use whole pans, but the smaller size is adequate for most purposes.

Artists' colors
Tubed artists' colors are made in standard sizes which may look small in comparison with oils or acrylics, but actually last a very long time.

INTRODUCTION

Gouache and acrylic

People often ask what the difference is between watercolor and gouache. The answer is that gouache is the opaque version of watercolor, and the two are often used together in one painting. Gouache can be used thinly to lay washes in the same way as watercolor, but it tends to give a slightly more chalky appearance depending on the colors used, because the lighter tones are obtained by adding white pigment.

Using gouache

Paintings in which gouache and watercolor are combined are usually begun with the latter, with the opaque paint used thickly for highlights, as in many of the demonstrations in this book. However, some artists use gouache like oil paint or acrylic, using it thickly throughout and working from dark to light. Because the paint is basically opaque, the colors don't run into each other as readily as do watercolors, and even quite thick layers can be painted over when dry—though take care here, as new applications should not be too wet or they will disturb the paint below. Gouache is also great for painting over acrylic, creating a nice matte finish that reduces the natural sheen of the acrylic and gives a three-dimensional look.

Acrylic

Acrylic paints are unique in that although they are water based, and diluted with water, they are impermeable once dry. This is because the pigments are bound with a polymer resin, a form of plastic. This has in the past led some artists to denigrate acrylics, referring to them as "plastic paints," but those who use them regularly appreciate their quality and their amazing versatility.

Additional equipment

Apart from brushes and palettes, shown on page 13, you need very little else, but masking fluid is an essential extra, as it enables you to reserve small or intricate areas of white without having to paint laboriously around them. Soft kitchen towels are useful for cleaning up, and can also be used for lifting-out methods, but if you don't want the texture to show in the artwork, use tissues or toilet paper instead. Small sponges are most often used for making corrections and lifting out, but you can also apply paint with them. Gummed-paper tape is used for stretching paper (see page 10).

Acrylic tubes
Tubes of acrylic can be bought individually or as sets of preselected colors.

Gouache paints
Gouache paints are usually supplied in tubes, about twice the size of watercolor tubes. As with watercolors, there is a wonderful array of colors to choose from—even metallic and iridescent colors, which are marvelous for special effects on wings, or for creating sparkles on jewelry. One of the disadvantages of gouache is that the tubes tend to dry out over time, so don't buy more than you are sure you will need.

TOOLS
AND
MATERIALS

Jars and bottles
Acrylic is sold in jars and bottles as well as in tubes, with the paint usually being slightly more fluid. If using jars, avoid dipping brushes directly into them unless they are perfectly clean, or you will dirty the color.

Students' and artists' color
Like most paints, acrylics are produced in students' and artists' versions. The students' colors contain less pure pigment, but are perfectly adequate as an introduction to the medium. Artists' colors vary in price depending on the manufacturer and the pigment used. Some pigments are much more expensive than others. Students' colors are all priced the same.

working Digitally

Your choice of computer is your preference. Apple Macintosh is the preferred system among digital-drawing professionals, but most industry-standard software is available on both Mac and PC. Most PC operating systems include a program that allows you to draw, paint, and edit images. Microsoft Paint, for example, is part of Windows, and although slightly primitive, it is a good place to start experimenting with digital drawing. You can draw freehand and create geometric shapes, pick colors from a palette or create new custom colors, and combine visual images with type.

Scanners also include a basic photo-editing and drawing package or a reduced version of one of the more professional packages.

INTRODUCTION

Computer
The Apple iMac is an ideal computer for digital artists.

Scanner
Most scanners have high optical resolutions that are adequate for scanning line work to be colored digitally.

Graphics tablet
A graphics tablet offers a more natural way of working than using a mouse.

Computer Design Programs

Photoshop

Photoshop is generally regarded as the best art-generation and image-editing package. It offers a wide range of tools for originating digital artwork, plus sophisticated output controls. Photoshop is the software most commonly used for professional print work, but it also offers tools for creating images for use on the Internet. It comes bundled with a dedicated package, ImageReady, for this purpose.

Although Photoshop can seem overwhelming as a result of the large number of tools and options, it's easy to come to grips with the parts of the software that you'll use most. There is a range of standard brushes and drawing tools and options for customizing them. The tool bar also has the usual digital equipment, including selection, drawing, and cloning.

Illustrator

Illustrator offers color options for linear work and solid areas. There are options to specify the weight and fill of the lines drawn and the usual range of standard and customized brushes is available, as is digital equipment such as selection, drawing, distortion, and cloning.

Painter

Painter is a highly specialized package, designed to simulate natural media such as oil paint and watercolor. Painter offers a huge selection of brushes and has excellent brush stroke control. Despite its many wonderful features, however, Painter lacks several simple image-editing facilities and forces lines to be anti-aliased, making screentone difficult to apply.

WORKING
DIGITALLY

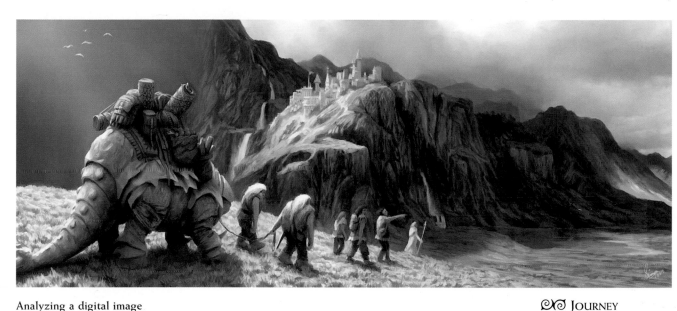

Analyzing a digital image

This image, inspired by the scenery in the *Lord of the Rings* movie trilogy, was created in Painter version 8.1.

JOURNEY
by Simon Dominic Brewer

As a final touch, a few dabs of white were added to represent birds.

The smaller and softer brushes were used for the more detailed work.

This area was gently blurred so as not to distract from the action of the scene.

The characters cross the canvas away from the viewer, following the base of the mountain range. This leads the viewer's eye into the scene and emphasizes the theme of a journey.

Sunlight on the grass nearest to the viewer is brighter and more saturated than the sun on the distant slopes. This helps to create an illusion of depth.

Large areas were blocked in with the big, square brushes. These general areas of color and form were defined first of all.

Chapter 1

VISUALIZING

The fantasy artist relies entirely on imagination to design each piece of art. The first important step is to invent the characters and set the scene before creating the surroundings and subjects, and adding the detail that forms finished artwork. Preparing several stages of rough drawings, or sketching all the elements to ensure each is convincing, and that they work together, saves time and energy on the finished art.

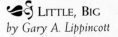

LITTLE, BIG
by Gary A. Lippincott

the Importance of the Sketch

Draw, draw, draw…
… then draw some more.
Use whatever paper is
available—the backs of
envelopes or loose pages
as well as sketchbooks—
to draw visual "notes"
that represent ideas.

Sketching is the so-called practice that makes perfect. It is
the single most important exercise in drawing what will
eventually become artwork based on your imaginative ideas.

Sketching gives the artist the ability to make
decisions about the initial ideas without fear of
messing up later by making mistakes that will be
time-consuming to correct. When making quick
and simple drawings of the subject, the artist
actually allows for changes to the art before feeling
locked in to ideas that eventually become difficult
to change because of the time and effort that has
been spent on them. Sketching also acts as a warm-
up exercise for your drawing, allowing for
more fluidity in the final piece. It is

a good way of overcoming mental blocks, or the
fear of how, and where, to start on a daunting sheet
of blank paper.

Creative thinking

Sketches allow the artist to consider other poses for
the characters, different viewpoints for a particular
scene, or the cropping of the overall design. They
even provide opportunity for starting over without
feeling that the time spent has been wasted. As
they usually take very little time, sketches also get

VISUALIZING

Fast sketching
Characters or objects might inspire
a fantasy story or scenario—
capture them on a scrap of paper
before they disappear!

Spiral-bound sketch pads
These allow for the page to be completely flat while
drawing, and for disposing of unwanted sketches. However,
you must never throw away a sketch, no matter what you think—it is
a captured visual idea and could prove useful as a creative starting point.

Pinhead

Sketches are visual reminders outside the head. Our imagination tends to flow fast and without conscious effort—we need to take notes to keep up!

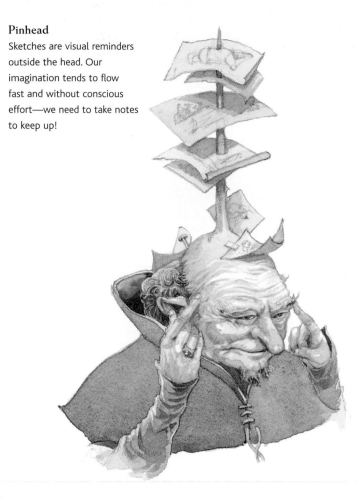

the creative part of the mind going and encourage a flow of many more ideas to choose from. For the fantasy artist these rough jottings can be a source of discovering a previously unimagined juxtaposition of two ideas that suddenly come to life as one unique concept. Additionally, sketches of the composition can be as small as a selection of small "thumbnails" to assess quickly the success of balance and focal point.

Consolidate ideas

Not only does sketching transfer our thoughts to paper so that we can refer to them later, but the persistent process of drawing also enhances our ability to represent ideas clearly. It encourages brain–hand coordination and, ultimately, becomes as natural as writing our names. Sketching from imagination and from the real world is equally important—even in fantasy art, the more realistic the characters, objects, and backgrounds, the greater the impact of the fantasy. Carry a sketchbook with you at all times, and try to record visual notes in it whenever you can. An hour waiting at the airport can be enjoyably spent observing and capturing characters, fleeting gestures, and expressions that can be filed away for future use.

Observation is an art in itself, and the more you sketch the better you will become at translating what you see before you onto the page. You will also start to pick up on the little details of everyday life that might have previously gone unnoticed. It is these details that make your work unique and special, and enrich the visual narrative.

THE
IMPORTANCE
OF THE
SKETCH

Imaginative sketching

Sketch from your imagination as well as from the world around you. Refer to your ideas later and try to develop them. The sketchbook is an ideal tool for combining your real-life observations with the creative limits of your imagination—an architectural gargoyle can come to life and clamber across the pages of your sketchbook.

The back of an envelope

An old cliché, but it pays to think in this way—be resourceful. Keep them tied up in a box, or send them to your friends.

Abstract Sketches

There are different types of sketches, each with a different purpose that serves the artist in various ways.

Some sketches are used to practice drawing or explore different ideas, and these are usually the ones found in sketchbooks. Others are prepared as a form of presentation—for example, to give art directors or editors an idea of what the artist has in mind. Then there are those very basic, almost completely abstract, doodles that help the artist plan the entire piece of art. They help in the placement of characters, architecture, landscape detail, and so on, before starting the finished work.

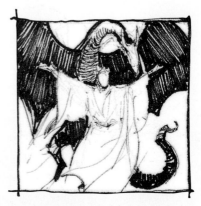

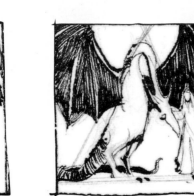

Simple and abstract
Keeping the subject matter in simple, almost abstract, form enables the artist to design the work by quickly changing the composition without worrying about the detail.

Balancing content
How much subject matter is on the left compared to the right?

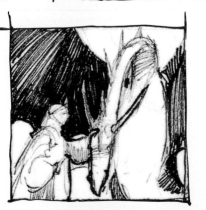

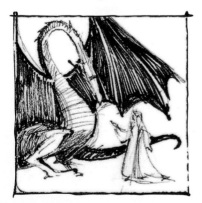

Attracting attention
Will the placement of the subject matter attract the viewer's attention as intended?

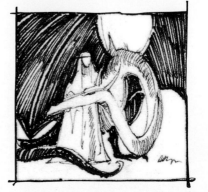

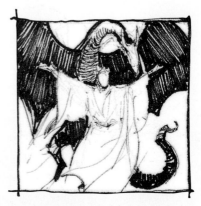

Balanced design

The overall design of a piece of artwork is very important, and attention to this is best done in an instinctive way. Keeping the subject matter balanced allows the viewer to see the various ingredients, or elements, of the art in the way the artist intended. The main characters, actions, architecture, landscape, and other features of the work will not all be revealed at once. It is the artist's job to design the art in such a way that the viewer is forced to look at some elements in a particular order, and with a certain level of attention. By making very rough sketches of the overall design, we exert a certain amount of control over what takes place in the viewer's mind when looking at the finished artwork.

Placing different elements
Playing around with the placement of the old woman, the doorway, and the surrounding landscape allows the artist to decide on which composition is best. The decision is to use the third sketch.

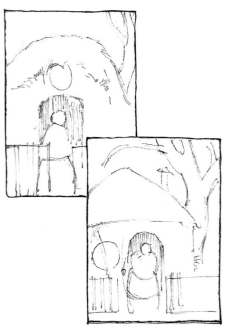

ABSTRACT
SKETCHES

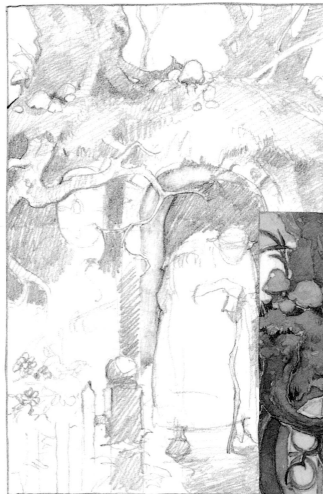

Important posture
By showing the entire figure, the viewer can "experience" the posture of the old woman.

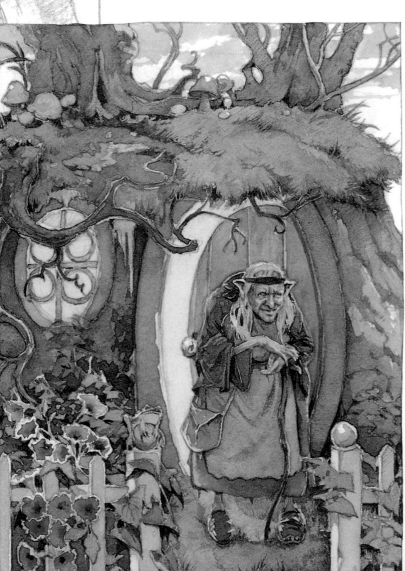

Background balance
There is just enough background showing to give the impression of a house built into a hill.

the Ingredients of Traditional Fantasy

Because the majority of us have been exposed to myths and legends since childhood, artists have documented these stories in their work, and it is these certain elements that consistently appear in works of fantasy.

VISUALIZING

In order to concentrate on the more traditional images used in fantasy, we'll refer to subjects taken from stories that have been told over and over again, for many years. Fairy tales and folklore have always included elements such as fairies, witches, princes and princesses, trolls, animals who act like humans (and sometimes visa versa), enchanted forests, and magical castles. Mythology has given us giants, demons, winged horses, centaurs, amazing journeys, and many, many heroes. A large amount of fantasy is centered around the legend of King Arthur, his knights, and the fair maidens, wizards, dragons, castles, and mystical realms that make up their world.

Make it consistent

Although the list of fantasy elements is long and varied, it's best to use only components that "belong" together when working on a single painting. This makes the artwork more convincingly real. Good fantasy art gives the viewer the sense that no matter how strange the subject, the artist has recorded an actual scene or event. To this end, it is important to be selective about what elements are painted into a single work. Good research into these myths and legends will help keep your subject matter consistent and believable.

Dragons
Dragons are to be slayed by knights and for terrifying maidens, or to be used as steeds on which to ride into battle.

Monsters and beasts
Orcs and trolls usually work in groups to form an army of darkness, a barbaric underworld horde bent on destruction.

Maidens and damsels
Maidens in folklore are innocents abroad. They are there to be protected by the heroes.

Buried treasure
In traditional stories, hidden treasure can be the trigger for a quest or journey.

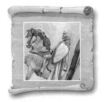

Heroes

Traditional fantasy abounds with heroes: boys and men. These are the guys who see the action and who make the journey, taking us with them.

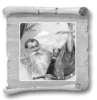

Wizards

There are evil wizards and benign ones. They are invariably bearded, grave, and wear long, flowing robes.

Fairies

Fairies are a whole sub-category in their own right. There are bad fairies and those that are fair and good. Whichever category they fall into, they are all closer to the world of spirit than matter.

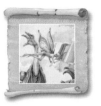

Castles

Castles are very often the place of incarceration for captured heroes and innocent damsels.

THE
INGREDIENTS
OF
TRADITIONAL
FANTASY

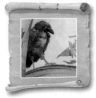

Witch's familiar

A helper, usually in the form of an animal, such as a toad, black cat, or raven.

more Elements

The world of fantasy is large and diverse, so much so that trying to define what it is becomes almost impossible.

There are so many types of fantasy that it would take the next twenty pages to list and describe them. So let's narrow it down to some of the more popular subjects—although "popular" usually depends on the particular part of the world you live in.

Historical fantasy

A large proportion of fantasy, whether written or from the mouths of storytellers, centers on historical subjects. Actual events, real people, and times are subjects for fantastical tales and myths woven around the retelling of the original subjects. Fairies, gnomes, witches, dragons, and other fantasy figures appear alongside stories about King Arthur (a legendary subject himself), the knights, and damsels of the era. Even J. R. R. Tolkien's *Lord of The Rings* seems to draw much of its subject matter from that particular place in time. The armor, weapons, costumes, entertainment, customs, and even certain attitudes come from the same historical mold.

Many roles of fantasy

Myths and legends probably arose from the need to explain aspects of our world that seemed unexplainable. In Greek mythology, gods were presented as the source of almost everything that happened in the physical world. The little-known regions of the earth, believed to be uninhabited, always had creatures living in them to keep people away. The depths of the oceans, because they were not easily accessible to man, were the focus of fantasies that were hard to disprove. The many different uses of fantasy, and their roles in human development, will always provide the fantasy artist with enough subject matter to draw or paint until the end of time.

26

VISUALIZING

Inventive minds
Man's inventiveness became an instrument that gave birth to the type of fantasy found in the stories of H. G. Wells and Jules Verne.

Vivid imagination
From legends of creatures surfacing through deep waters, to tales of beings of enormous size, throughout history human imagination has kept fantasy alive and well.

Mythology

The gods of mythology were responsible for a vast number of fantastical beings and creatures.

Large-scale characters

The man and his ox look quite normal until you focus on the foreground trees over which they tower. When dealing with super-size beings, it is vital to include something that explains the scale.

Deathly fantasies

Even death, and the ability to cheat it, are popular subjects in fantasy art.

Animal characters

Another type of fantasy derives from fables that bestow human characteristics on animals to describe our shortcomings.

MORE
ELEMENTS

the use of Narrative Elements

 Good fantasy art always has something to say: maybe it relates a story or expresses an idea; maybe its purpose is to create a mood or conjure up a memory.

This visual "language" adds interest and makes the art more thought provoking. A number of elements help a painting tell a story. Of course, the main subject—whether a dragon, a group of elves, or a fairy princess—tells most of the story, but it can be broadened, enriched, or parts of it emphasized by including other ingredients too. Often the addition of secondary characters can help explain the main character's purpose or actions.

Using props

The use of props can add to the narrative aspects of the art by describing a character's job or alluding to what the character will do next. Sometimes the composition of the painting becomes a narrative element in itself. A painting of a castle perched atop a large range of mountains with nothing else around for miles tells a different story than one of a cluttered interior of the same castle. Even choice of colors can influence the narrative by creating a sense of a mood.

28

VISUALIZING

The limited palette of colors used in the background landscape were carefully chosen to enhance the feeling of doom and bleak foreboding.

What's the story on the menacing castle remnants in the background?

The writing contorted branches echo the anguish of the central character.

The main character obviously has a story to tell. His posture indicates his anguish and intense pain.

The few props—a crown, sword, items of clothing—indicate that the character may have royal blood. What has this man done to deserve his fate? Does the fact that he is of royal descent explain the reason for his predicament?

Glowing ochers and yellows make the figure the focal point of the painting. The eye is then led into the mysterious landscape beyond.

Are these the fires of hell beckoning to the figure?

 METAMORPHOSIS
by Gary A. Lippincott

REMEMBER THIS
While sketching ideas for a painting, ask yourself:
• Is there some interaction between the main and secondary characters for the purposes of telling the story?
• Does the setting give enough clues to the painting?
• What props or costumes will help explain a character's purpose?
• Have I created the right mood for the intended story?
• Are there elements that raise questions in the viewer's mind?

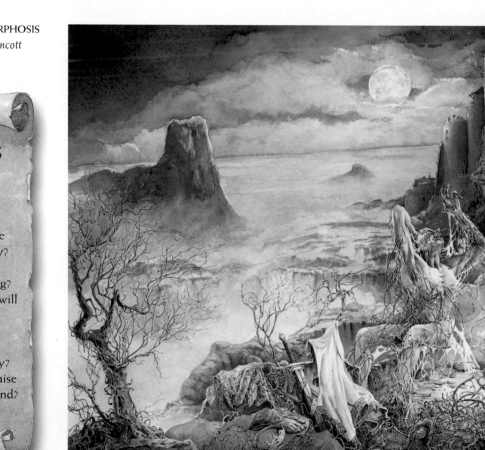

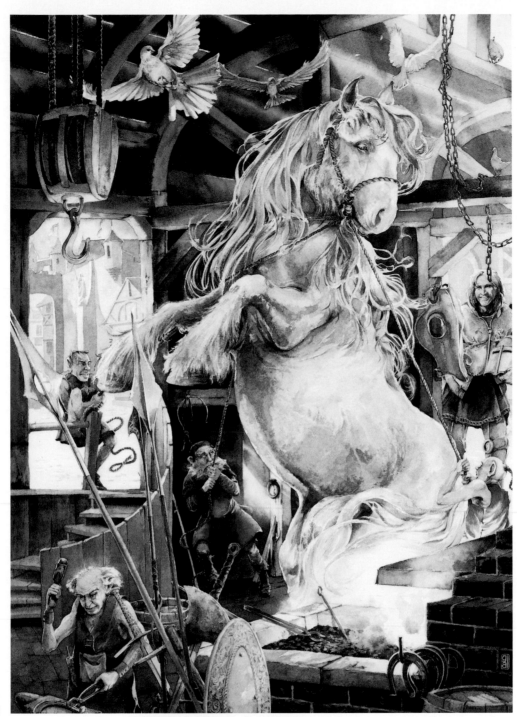

A SHOEING
by Gary A. Lippincott

The birds rise up as if they have only just been disturbed by events.

Light pours in from the doorway, illuminating the scene.

The horse's handlers show signs of distress trying to control the mighty horse.

To the blacksmith, this is just a routine part of his job.

The dark wooden beams and shafts of sunlight create the atmosphere of a medieval church.

The horse's posture tells us that it wants nothing to do with what the blacksmith and his assistants have in mind. Yet, the horse's expression suggests that it is neither frantic nor very frightened. This is probably a playful attitude.

The knight's expression and relaxed posture support the idea that nothing is amiss. On the contrary, he seems to be enjoying himself.

The horse appears to be emerging from the smithy's fire, giving the impression that a towering stallion is being forged out of the heat and smoke.

Ideas and
Influences

 It is hard for most people to understand how fantasy imagery can be drawn or painted because there are no models to look at in reality.

A common question that every fantasy artist is asked is "Where do you get those ideas?" or "Do you see these things in your dreams?" There are many sources of information from which the fantasy artist constructs an image that does not exist. They can be narrowed down to three basics.

The written word
This must be the largest of the three basic sources of imagery. There are countless stories, tales, fables, legends, and all forms of folklore that describe, sometimes in amazing detail, images of magical places, creatures, and people that make up the world of fantasy. From the myths of ancient tribes and peoples, to modern-day authors, there is much descriptive writing to provide the fantasy artist with a starting point for designs.

Past artwork
The second source of reference has to be artwork of the past. Using descriptions from stories, artists have produced artwork that provides existing visual interpretations of writing. The Old Masters painted scenes from mythology. The Pre-Raphaelites were prone to painting scenes of mythology—for example, Waterhouse's "Ulysses and the Syrens," and Arthurian legends, such as Sir Edward Burne-Jones' "The Last Sleep of Arthur in Avalon."

Imagination
Today's fantasy artists use both the above sources in conjunction with their own imagination, which is the third and most important source. Putting individual interpretation on written stories and existing artwork is what makes today's fantasy artist successful at creating something new and fresh from past sources.

Visualizing

Old manuscripts
Because the illustrators of ancient manuscripts had less opportunity than we do to study human and animal anatomy, their work often has a strong fantasy element.

Et erultauerunt filie iude: propter
iudicia tua domine.
Quoniam tu dominus altissimus
super omnem terram: nimis exalta
tus es super omnes deos.

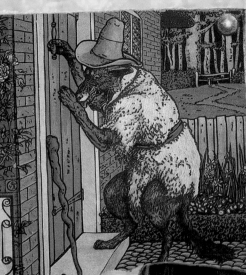

But in the meanwhile the Wolf went, with a grin,
 At the Grandmother's cottage to call;
He knocked at the door, and was told to come in,
 Then he eat her up—sad cannibal!
Then the Wolf shut the door, and got into bed,
 And waited for Red Riding Hood;
When he heard her soft tap at the front door, he said,
 Speaking softly as ever he could:

Traditional tales
The story of Little Red Riding Hood has reappeared in many collections of stories. This is an image from a 19th-century illustrated book for children, with a slight element of caricature.

Different interpretations
The same story of Little Red Riding Hood is more chillingly interpreted by the 19th-century artist Gustave Doré, whose work has inspired many later artists.

Art of the past
Strolling around art galleries will often give you ideas for both characters and settings. Pre-Raphaelite paintings—such as *Isabella and the Pot of Basil* painted by William Holman Hunt from 1866–1868—with their close attention to styles of clothing and the textures and rich colors of surroundings are a good starting point.

Historical references

Many fantasy subjects seem to center around certain periods, real or mythical; for example, mythological settings and Arthurian legend feature prominently in the genre. The work of Shakespeare, Biblical texts, writings of spiritualism, and fairy tales from around the world influence the subjects of fantasy art. Therefore, it is important for the artist to have references from, and for, such historical sources and eras. Pictures of period costumes, weaponry, architecture, furnishings, and scenery should be filed for future reference. These can be used as they appear or they can be altered creatively—simply having them in view helps the artist maintain a sense of reality in the work.

Personal sources

My studio is filled with reference books, prints of paintings (from past and modern fantasists), plastic models of monsters and comic book characters, rubber masks, puppets, sections of vines, and anything else that will inspire me when I gaze up from my artwork. It is hard to keep the inspiration going sometimes and that is when it is essential to have such ready sources of stimulation. I leave books open on pages that are filled with the kind of art that inspires me; for example, *Fairies* by Brian Froud and Alan Lee is always nearby. This is not so much as a source of imagery but to inspire me.

My walls are cluttered with prints that stimulate my imagination. From past artists such as Alma-Tadema, Arthur Rackham, J. W. Waterhouse, Bouguereau, John Bauer, Edward Robert Hughes, Howard Pyle, and Maxfield Parrish, to modern-day masters such as Brom, Frank Frazetta, James Christensen, The Hildebrandts, and many others. Their artwork inspires me to do the kind of work I fill my days with.

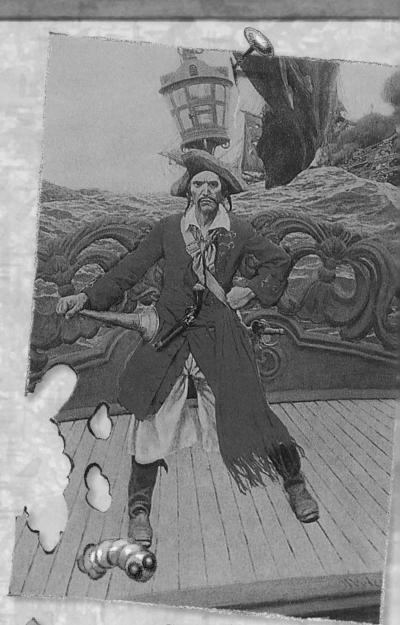

Changing styles

The American artist Howard Pyle changed the way adventure stories were illustrated in books such as his *Book of Pirates* from 1902. Previously they had been flat and stagy, but Pyle focused on the action and dynamics of the scene in a way that was quite new.

The "Golden Age"

The artist–illustrator Maxfield Parrish, whose career lasted many decades, did more than any other artist to shape what is known as "The Golden Age of Illustration" in America, and his influence is still felt several decades after his death. This painting dates from 1914 and is from *The King Albert Book*.

VISUALIZING

The fairy world

In his gentler illustrations, such as those to J. M. Barrie's *Peter Pan in Kensington Gardens*, Arthur Rackham conveyed the delicate fragility of the other-worldly beings to give a strong feeling of the reality of their world.

Using the camera

Take a camera wherever you go, so that you can record any unusual and exciting effects. Or collect photographs by professional nature photographers, like this one, which was taken from a low viewpoint so that the tree is distorted, and has a strong fantasy feel.

Woodland creatures

The haunting, dreamlike style of the British artist Arthur Rackham at the end of the 19th century has had an enduring influence. Some of his illustrations for children's books are distinctly frightening for the young, but for the fantasy artist they are perfect.

Character Studies

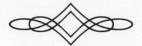

What would the world of fantasy be without all those strange, twisted, heroic, wizened, deformed, battle-worn, or beautiful inhabitants?

Nothing tells more of a story or makes a piece of artwork more visually interesting than a fantastic-looking character. Not only is it important to make these characters fit into the environment they are made to occupy, but also they should impart a sense of being as real as any other element of the art. Distorting facial features and body structure, which is necessary most of the time, can also prevent the characters from looking "real," making them resemble cartoons or caricatures instead of living, breathing beings.

Small and gradual changes

One of the best ways of keeping a character realistic when transforming it into a fantasy figure is by being careful to make whatever changes are needed in small increments. Start by changing the basic shapes of the head and body, attempting to keep the underlying musculature or skeletal structure relatively the same as on a normal model. The features can be exaggerated in length or bulk, but they must still attach at the same points on the body and remain true to the direction in which they run on a normal subject.

Of course, this holds true only for characters that retain the overall look of people or animals in nature. If the being is constructed with no resemblance to reality, then all this effort to retain real anatomy should be ignored. Let the imagination take over.

When the basic shape of the head and body is established, start exaggerating the features. If a longer nose is needed, extend the length at the same time carefully keeping the visible structure the same. If a wider mouth is required, extend the lips, trying to keep their basic shape intact. This mixture of real anatomy and exaggeration is important to create the illusion that the character is not a cartoon but that it exists somewhere in reality.

34

VISUALIZING

Departing from the prototype
This elderly warrior, with his flowing beard and chubby face, is very much an individual character, more reminiscent of Santa Claus than of the more usual lean, powerful prototype warrior.

Physical characteristics
These gnomelike beings are distinguished by their extreme, almost skeletal thinness, which creates a rather disturbing impression. The head of the left-hand figure is clearly based on an actual person, but the large ears place the creature firmly in the fantasy world.

Reality into fantasy

The figure and posture of the old woman is highly realistic, but the creature on her back and the small figures in the basket take her from the real world into a far less pleasant one.

Half man, half beast

This being, a man combined with a horse, wolf, goat, or other creature, is well known in myth and fantasy art, but here the creature is given a more human feel by the highly naturalistic treatment of the head. Without the huge, pointed ears, this could almost be a portrait of a real person.

Exaggerating facial features

With the basic shape of the head established, facial features can be gradually altered, enlarged, and changed in any way that suits the subject, thus transforming an actual being into a fantasy one.

CHARACTER
STUDIES

VISUALIZING

Selecting a model

It is helpful to have a real character pose for the model of a
fantasy character. Choose a model as close as possible to the
desired character, as this makes it easier to change certain
features, yet retain enough to keep the fantasy face alive.

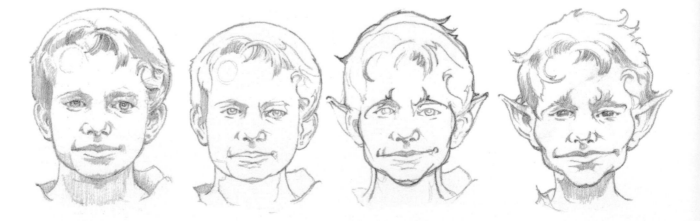

Creating an old woman

The artist's model has some of the desired characteristics that are embellished using imagination without losing the real structure that makes them look convincing. Notice how much the character changes by altering the shape of the head alone.

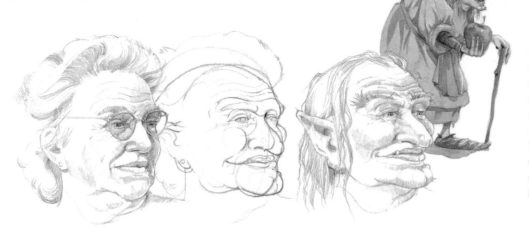

Changing the features

For a better chance of making a more convincing character, keep wrinkles where they should go, shadows in the places they would naturally appear, and muscles in place. Notice how many of the basic features have been retained—some are lengthened, some made heavier, and others left untouched.

Photograph of a musk-ox skull used for reference.

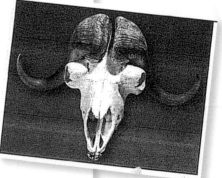

The water-buffalo man

In spite of an elaborate transformation from man to almost beast, a large portion of the real features remain the same. The shapes of the mouth, chin, and throat become enlarged while retaining the characteristics of the human model—the corners of the mouth, shadows around the chin and lips, and so on.

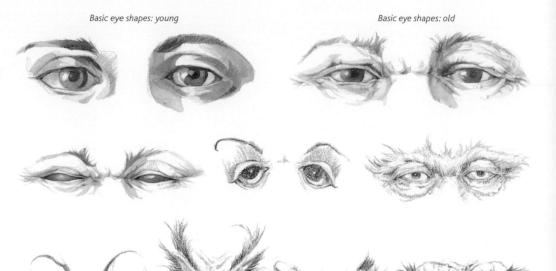

Basic eye shapes: young *Basic eye shapes: old*

Mirrors of the soul
The eyes are said to be the mirrors of the soul, and this is especially true in the fantasy world. Eyes are perhaps the most effective means of portraying the intent and emotion of your character. Here, the basic eye shape is adapted to a host of scary or scared people.

VISUALIZING

capturing Facial Features

& Let's get ugly! Face it, fantasy characters are either strangely beautiful or wizened, humorous, or grotesque.

The right combination of facial features on a character can express much of what the art seeks to portray. It's a good idea for the artist to examine the features of a normal face, and try to retain as many of them as possible.

Lengthening or shortening features

By lengthening or stretching the features, the subject can be turned into an elf, wizard, witch, zombie, or any character that has longer features than those considered as normal. In contrast, by shortening facial features, the character takes on the appearance of an imp, troll, and a multitude of animal–human combinations. The addition of scars, warts, wrinkles, and facial hair can greatly enhance the look of a fantasy character. Don't be afraid of exaggerating the features to what you might initially regard as too extreme—use your sketchbook to gradually transform your character from normal to fantastical. Consider the way in which caricaturists of political cartoons push facial characteristics to the extreme but manage to retain

Shared looks
Hard to believe that the plain face on the left was the starting point for the dramatic face that emerged.

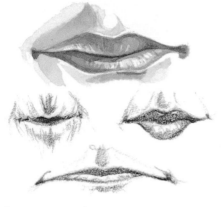

Lips, noses, and ears
These can also be very telling: are they thin, mean, and pointed, or generous and rounded? Or do they portray slight animal traits, perhaps to imply impishness or bovine slow-wittedness?

the original likeness. They are purely concerned with capturing the essence of their characters. As a fantasy illustrator you need to convey the character, and this can be achieved by including observed and fantastical details.

Eye structure: the mirror technique

Start noticing the differences in the structure of eyes. Most of the time, the eyeball remains normal, even though the lids and the overall shapes change. If a model is not available, use a mirror on yourself. Try making expressive looks with your eyes and notice what details have to change for certain expressions. A curious little fairy's eyes would probably be squinty slits, while an inquisitive wizard would have his eyebrows raised, and the eyelids wide open. Disney animators used the mirror technique to achieve a lot of the expressions on the characters they drew. It's a good idea to start a file of expressions in a sketchbook.

Nose, mouth, and ears

The same holds true for the nose, mouth, and ears: it is necessary to change these features by stretching, flattening, or shortening, while at the same time keeping the internal anatomy intact.

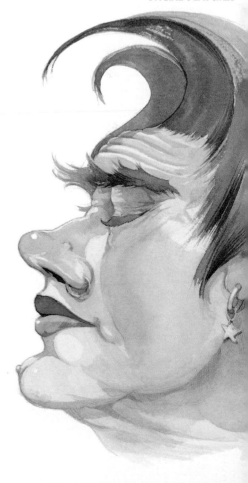

From feminine to fantasy
By deciding which aspects of the features should be the same—for example, the bone of the nose, the corner of the mouth, the shape of the eye, and so on—the realism of the model can be carried over to the fantasy version.

Body Stature

From the smallest of fairies to the gigantic stature of lumbering giants, the world of fantasy has fewer physical boundaries than reality.

Although there are extreme differences in size, posture, and carriage of people's bodies, the differences are more varied in the world of fantasy. Even within certain groups of fantasy characters there are greater differences than in the real world.

Fairy features

Fairies come in a wide range of sizes, from the almost-invisible ones that flit about under the flowers and ferns, to the "brownie types," large enough to accomplish tasks that require more strength than humans exert. Even within the fairy group there are differences in body types among fairies of the same size. The anatomy of some may resemble that of humans, though others have a more exaggerated look. Extremely long arms, large feet, heads that are proportionally too large for bodies, hunched backs, and short and bowed legs are just some of the features that fairies of every size may have.

Dwarves and gnomes, usually associated within the realms of fairies, are customarily stockier and more muscled than fairies, yet close in stature to many of the fairy types.

Middle-size characters

There is a host of other fantasy characters between the groups of fairies and the giants, including kings and queens, princes and princesses, wizards, knights, and warriors. These are of normal human size (or slightly taller), and it is possible to work from normal human models.

40

VISUALIZING

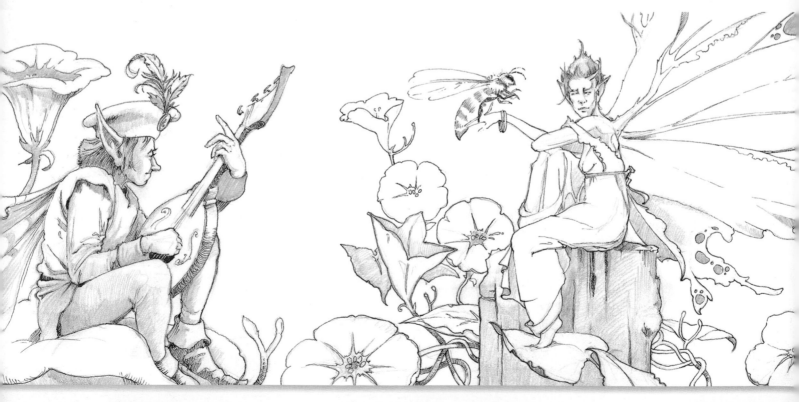

Fairy forms
Fairies come in many forms, with different body types, ranging from tiny, exaggerated characters barely visible among plant life, to larger beings that resemble the human form.

Big bodies: ogres, trolls, and giants

At the other end of the size scale, there are the ogres, trolls, and giants. They are usually depicted larger than humans, with bodies that give the impression of enormous strength and fortitude. Muscled arms and legs are appropriate features for this group that seems to rely on brute force to get things done. Tossing rocks and smashing through trees requires this type of build. Usually, their heads seem small in proportion because there is no great need for brains in their daily existence.

Strength and fortitude

Giants and large, or brutish, fantasy characters are larger than human size, and they are depicted as hugely strong, with powerful muscles. Their small heads indicate that they have few brains, and they rely on their physical strength to smash through their daily tasks.

41

BODY STATURE

Attitude of Characters

 Good fantasy art tells the viewer a story, and its narrative qualities come from a variety of ingredients, including the attitude or personality of the characters.

Lavish backgrounds transport the viewer to the place where the story happens. Costumes are the "signposts" to different aspects of the story—for example, are we in a harsh climate or somewhere in the tropics? Another element of the artwork that helps tell the story is the apparent attitude of the characters. It is important that the artist gives the viewer the correct impression of the character's attitude. The personality should fit the action, mood, or storyline.

Facial expression and body language

Unless there is reason for contradiction in the art, characters are very serious looking during battle, conjuring, royal processions, and similar occasions. Fairies engaged in performing a "reel" or a party would have looks of mischievousness or elation on their faces. Keeping the characters' attitudes consistent with the narrative elements makes for a realistic piece of art.

VISUALIZING

Inner peace
A peaceful, blank stare gives the impression of a character being all-knowing, with a certain amount of inner peace.

Beyond reality
The expression on a wizard in the act of making magic can only be described as powerful, commanding, and having the ability to look beyond reality.

Chivalry and honor

Characters who possess characteristics of heroism, chivalry, or honor should be posed with that kind of attitude. A look of intelligence and wisdom helps to convey these traits.

43
—

ATTITUDE OF
CHARACTERS

Up to no good

A troublemaking imp would certainly look mischievous and "up to no good." The squinty eyes and overall smirk on this imp's face tells us volumes about what he's thinking.

Killing machines

A character that represents more of a killing machine than any other qualities would have a look of uncontrolled ferocity on its face.

Nature in Fantasy Art

Mother Nature plays a vital role in providing fantasy art with both characters and settings in which they can dwell.

Very often, the hidden places in nature—the deep, dark forests; the treacherous mountain ranges; and even the fern-floored, dank, earthen underbrush—make perfect settings for fantastical creatures or beings to inhabit.

Nature's hiding places

In legend and lore, it seemed that where humans found it hard to gain access, there sprang forth the possibility that such places were inhabited by creatures using their environments as hiding places. Humans seemed always to catch sight of the creatures by accident and were lucky—or unlucky, depending on the consequences—to have recorded their existence at all.

REMEMBER THIS
When recording nature
• Take easy-to-carry equipment.
• If working in a monochrome medium, make notes about the colors.
• Always carry a sketchbook and camera—you never know what you may see.
• Make individual studies of leaves, toadstools, flowers, and so on.
• Take photographs of fast-moving small creatures, butterflies, and birds.

44

VISUALIZING

Up close and interesting
Learning to draw and paint from nature ensures that the fantasy artist has a large source from which to select background art.

SOMEWHERE MAGICAL
by Gary A. Lippincott

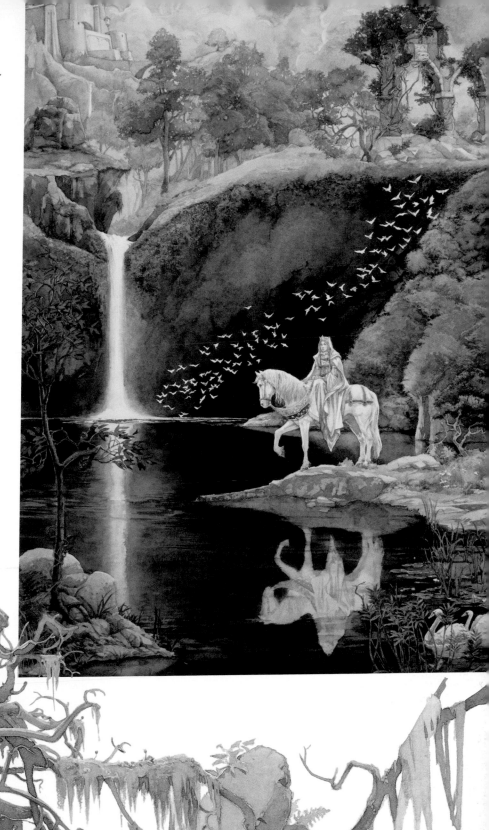

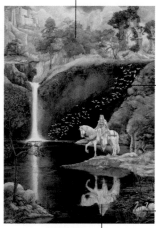

Naturalistic, well-observed trees and clouds contrast with a fantasy castle, where the magical being may dwell.

What has startled the flock of birds? Or could they be carrying a message?

The ethereal beauty of gliding swans reinforces the fantasy element.

The perfect reflections of horse and waterfall highlight the unnaturally quiet calm of the dark water.

Mysterious and exotic

The more mystery the fantasy artist paints into the landscape, the more successful that artwork becomes. Therefore, it is advantageous to discover nature's mysterious places, either by traveling with sketchbook and/or camera in hand or by collecting pictures of exotic places from magazines and books. Places where the plant life or rock formations take on a human quality are particularly good. For example, branches of trees that reach out, vines entwining themselves around each other, and boulders that seem to wear facial expressions are all elements that heighten the effect of fantasy art. Even placing a normal character in an environment with these features can become a work of fantasy.

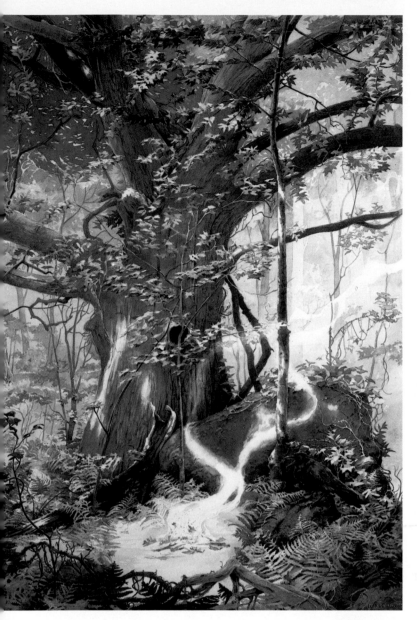

❧ PRESENCE
by Gary A. Lippincott

Holes in a tree trunk always give a suggestion of a possible dweller in the dark interior.

Overall low-key tonal structure, using mainly middle-to-dark tones, creates a somber effect.

The hint of a rising sun —within minutes the scene will become ordinary and the sense of mystery be lost.

Swirls of mist reinforce the overall impression of damp woodland at dawn—where anything fantastical might happen.

Twisting branches would look normal in a sunny scene, but are more mysterious and suggestive in a dim light.

Confirming fantasy qualities
By adding a few characters in your fantasy landscape illustration you can reinforce ideas about scale.

Character Interaction

The interaction between the characters portrayed in fantasy art gives the viewer a hint of the story behind the scene.

Fantasy art almost always tells a story and therefore there is a considerable amount of interaction between the characters it portrays. Sometimes the art is about a battle that has taken place or a ceremony of significance. Groups of characters acting out a combined role become the source of interest in the art. Even single portraits of fantasy characters should have their own stories to convey. What spell is that wizard conjuring? Does that warrior stand a chance in battle?

Character–animal interaction

Scenes of fantasy characters interacting with animals have been favorite subjects for many years. Major influences for this type of art have come from stories and poems written by such authors as Shakespeare, Lewis Carroll, Charles Kingsley, and J. M. Barrie. For example, fairies ride on small mammals, birds, and insects; elves steal from squirrels' nests; and a little girl follows a white rabbit down a hole in the ground. It is important for the artist to learn how to sketch nature studies, as the more realistic the animals are in the art, the more convincing the finished painting will be.

VISUALIZING

∞ **FLYING MESSENGER**
by Gary A. Lippincott
The relationship of fairies, imps, and other such small creatures with birds crops up constantly in folklore and fantasy. Here the large black bird is the trusted means of transport for the tiny messenger.

∞ **SPRING THAW**
by Gary A. Lippincott
In this lovely watercolor, showing an old couple in New England taking advantage of the spring thaw to do their washing, the artist has shown how his real surroundings appear through the eyes of a fantasy artist.

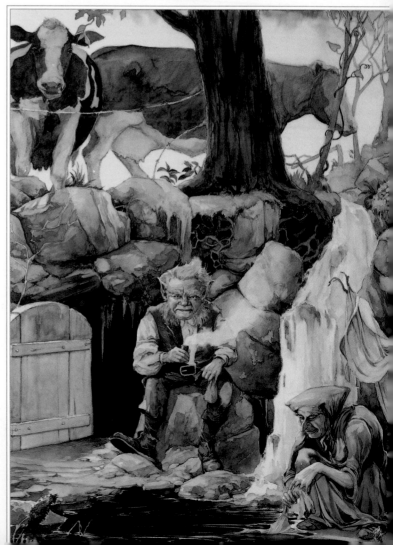

CHARACTER
INTERACTION

∞ OFF TO THE BALL
by Gary A. Lippincott

In the fairy world nothing can be taken for granted, and the artist has freedom to play with the characters and alter their relative scale in any way he chooses. Notice the size of the rabbit in relation to the carriage and its occupants, and the huge-seeming butterflies pulling a seat full of tiny implike creatures.

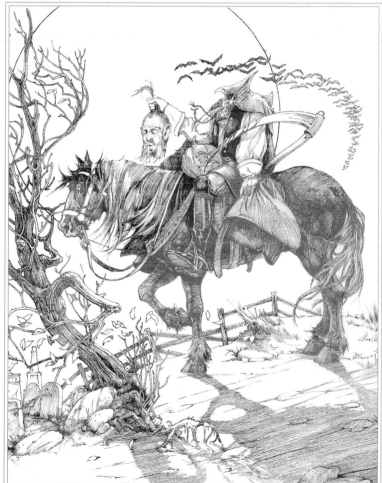

∞ THE HEADLESS HORSEMAN
by Gary A. Lippincott

This pen-and-ink drawing of a horseman carrying his own head was done as an invitation to a large Halloween party, given by the artist every year. Seen in this context, it is less macabre than it first appears.

Chapter 2

DRAWING

By building the artwork around simple drawings, the artist simplifies all aspects of the work, making sure the figures interact with their surroundings to create a believable scene. It is easier to see where detail is required when starting with basic outlines. Using a few simple techniques, the artist creates characters without having models, develops scenery from imagination, and breathes life into imaginary creatures.

 THE SORCERESS
by Gary A. Lippincott

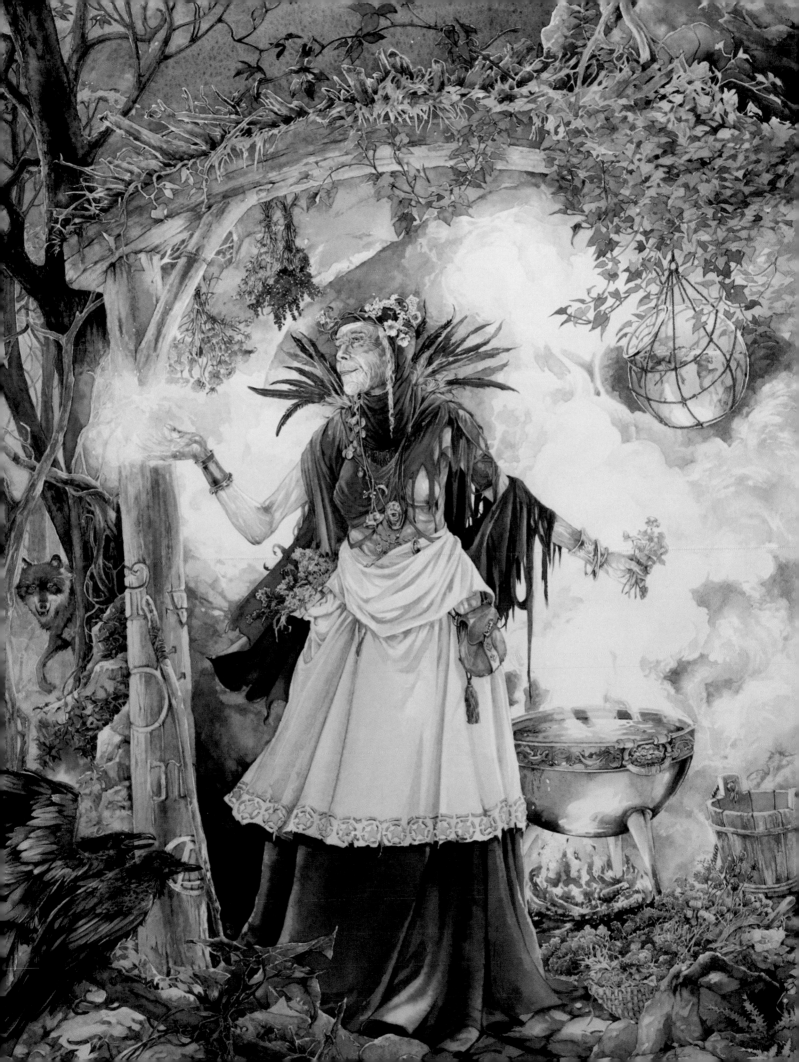

using Geometric Shapes

Since fantasy art is so dependent upon the imagination, we must find an imaginative way to draw it. Photography and models are used in this genre but fairies "flitting" are hard to photograph, and how long can you expect a dragon to pose?

The best way to draw that which can't be photographed or posed is by "building" them out of simple shapes that become the structure to add details to later. The basic shapes that can be used to build upon are the cube (which, when any of its sides are lengthened or shortened, becomes a box), cylinder, cone, and ball. Notice that all of these shapes are three dimensional. These are used because, for the most part, you are trying to put three-dimensional subject matter into your paintings. An important exercise in this basic shape technique is to learn to draw these shapes from every angle imaginable and as realistically as possible. To help you with this exercise, you may want to use models of these shapes, such as wooden blocks, containers, or those shapes they sell at craft stores to make decorations with.

DRAWING

Cube
A cube, when viewed from one side and directly at eye level, resembles a two-dimensional square. But by turning it to the left, right, up, or down, you can see sides that recede toward the background. Anything that you are trying to draw must also recede, its "lines" following the sides of the cube.

Cylinders
Cylinders play a large role in representing muscles in man or beast, while cones are used similarly to show the effect of shapes that come to a point, (chins, horns, spearheads, caps, and so on).

Boxes and elongated cubes
Rectangular boxes or elongated cubes are used to lay the foundation of a variety of objects, architecture, and living forms. Sometimes the use of these rectangular boxes and cylinders is interchangeable. They almost do the same "job" of representing the basic, underlying shape of things.

IN A NUTSHELL
• Almost everything you need to draw is a solid mass that has a basic underlying, geometric shape.
• By attaching and altering these shapes, the result becomes the foundation upon which you can "build" your drawing.
• Observe how perspective (the illusion of distance) is influenced when these shapes are turned toward or away from the viewer.
• The geometric shapes will eventually need to be altered to define more of what is being drawn. Example: cylinders will need to take on the look of muscles when using them to draw a human figure.

Seeing shapes

While observing things around you, try to see if you can break them down into basic shapes in your mind. Practice "seeing shapes" by tracing off photographs, as in the step-by-step sequence, right. By getting used to "seeing" in this way, it will be easier to decide on shapes to begin your drawing with when you are faced with a blank sheet of paper.

Develop x-ray vision! Keep in mind the backs of cubes, the far end of cylinders, and all that would be out of view.

 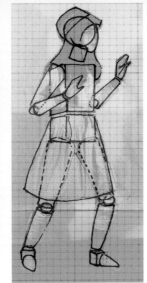 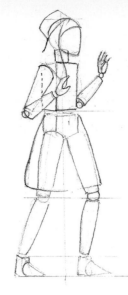

1 Find a photograph of a subject that appeals to you.

2 Lay gridded tracing paper over the image. Trace off the basic forms, rendering them as primitive shapes.

3 Transfer the traced image to drawing paper.

USING
GEOMETRIC
SHAPES

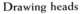

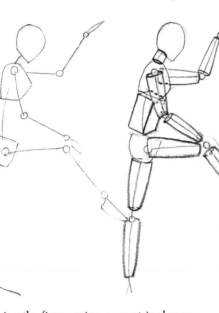

Drawing the figure using geometric shapes

1 When drawing figures, it is particularly important to start out with a gesture made up of a few lines. Everything that follows will "attach" itself to this simple structure (see pages 56–57).

2 Make the figure more substantial by attaching muscles and major bone structures, represented by cylinders and boxes. (Notice that the joints are represented by balls, which, in fact, they are in real life.)

3 Redefine the geometric shapes so they resemble actual anatomy.

4 Place the clothing and details on the figure, keeping all the three-dimensional aspects of the drawing in mind. (For example: the dress falls on both sides of the legs—show this.)

Drawing heads

Heads are basically balls and cones that fit into cubes or boxes (see pages 54–55 for more information). When these boxes turn or tilt, the basic shapes inside—and the features on those shapes—will be affected by the turning of the box.

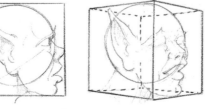 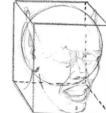 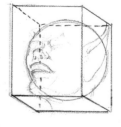

creating Heads and Bodies

The artist's skill in creating believable characters from imagination develops with the ability to see figures as a series of simple geometric shapes. Understanding how to manipulate the shapes in an imaginative, yet lifelike, way enables the artist to bring fantasy forms to life.

Simplifying features and figures

When starting to draw, it is important to study each feature and see how it is made up of a combination of smaller versions of the basic geometric shapes used for the whole figure. For example, the overall shape of the head is made up of a ball to form the top of the cranium, and a rounded cone for the lower face and chin. When these are drawn to the required size and proportions, the features of the face are introduced as smaller versions of the same basic shapes. The nose, mouth, brow, cheeks, and so on are drawn by attaching more basic shapes to the outline of the head. The nose is a small cone, and it can be lengthened, shortened, or widened. It can be positioned to appear drooping, or adapted in other ways to represent the character.

54

DRAWING

Working with a simplified head
Keeping the shapes of the head simple at first allows the artist to visualize it from different angles.

Front view
The features can be indicated by oval shapes, triangles, and circles. The triangle from the top of the ears—which line up with the eyebrows—to below the chin helps to place both accurately.

Side view
Further circles and ovals can be drawn for the forehead, cheekbones, and curve of the mouth.

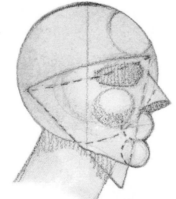

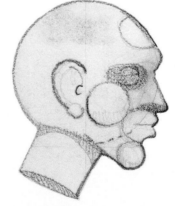

Side view refined
With the basic shapes established, the features can be refined, and the ears added.

Looking up
This is also a foreshortened view, with the underside of the chin, top lip, and nostrils clearly visible, and the top of the head much reduced in size.

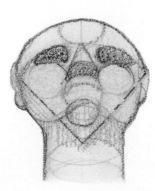

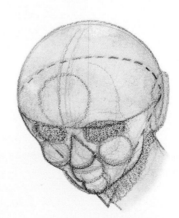

Looking down
In this foreshortened view, more can be seen of the top of the head and less of the features, with the nose now making a curve at the bottom, and the chin almost hidden by the mouth.

Shapes within shapes

Individual features are built up by adding smaller geometric shapes. For example, there are shapes within the conelike outline of the nose. A ball on the end will create a bulbous nose. A rectangular box where the nose attaches to the face will give the character more of a hooked nose. Once all the details are sketched in place as simple forms, they can be drawn again carefully, making them more anatomically correct.

Small shapes
You can apply the same rules of using shapes to the smaller facial details. Circles are useful for the curve of an eyebrow and the bumps in a nose.

Playing with simple shapes
Anatomical details, and human features, can get in the way when the artist is trying to picture the end result, so it is easier to begin by exaggerating simple shapes to create a fantasy face.

CREATING
HEADS AND
BODIES

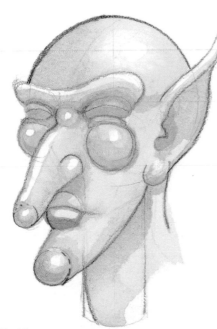

Building up
The face is beginning to take shape, with the long nose and chin, and prominent brow ridge, giving it a caricature look.

Finishing touches
The addition of facial hair, detail in the features, and the earring have created an individual rather than a caricature.

The fundamental figure

Like the head, the body is made up of simple geometric shapes drawn in perspective. They change as the point of view changes, when some parts have to be exaggerated, or when the figure moves. The body includes more three-dimensional geometric shapes than the head, but their purpose remains the same—to help visualize the anatomical features of a character when there is no model for the drawing.

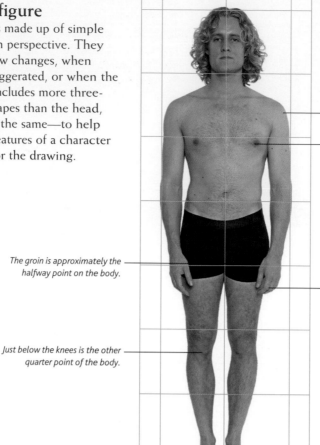

Head and body

With slight variations, the body is about seven and a half heads high, so artists use the head, from the crown to the end of the chin, as the basic unit of measurement.

Shoulders are wider than hips.

The nipples are approximately one quarter point of the body.

The groin is approximately the halfway point on the body.

With arms relaxed, the hand reaches below the tops of the thighs.

Just below the knees is the other quarter point of the body.

DRAWING

Simplifying intricate anatomy

The anatomy of the body is more intricate than that of the head, and more shapes are used, and connected. The body is made up of a series of cylinders attached to rectangular boxes. These are attached to balls, and then to cones, or more cylinders. The better acquainted the artist becomes with the shapes that represent different parts of the body, the easier it becomes to build the figure.

Complex shapes

The fantasy figure takes a normal body shape and distorts its parts. In these drawings, the cylinders, boxes, and other shapes are exaggerated to create the foundations for the figure of an old crone.

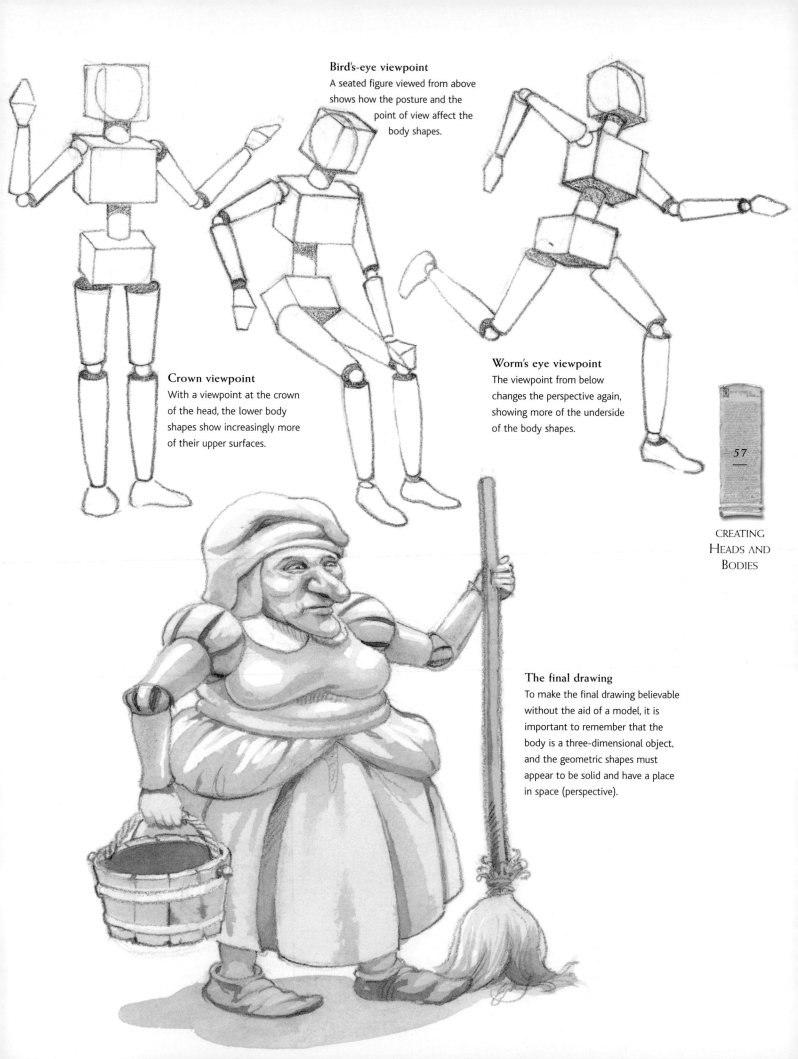

Bird's-eye viewpoint
A seated figure viewed from above shows how the posture and the point of view affect the body shapes.

Crown viewpoint
With a viewpoint at the crown of the head, the lower body shapes show increasingly more of their upper surfaces.

Worm's eye viewpoint
The viewpoint from below changes the perspective again, showing more of the underside of the body shapes.

The final drawing
To make the final drawing believable without the aid of a model, it is important to remember that the body is a three-dimensional object, and the geometric shapes must appear to be solid and have a place in space (perspective).

57

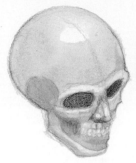
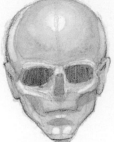
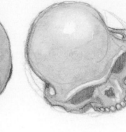
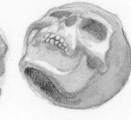
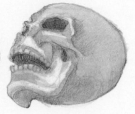

Anatomy Primer

Understanding a few essential aspects of anatomy will help the artist produce convincing fantasy subjects. Even creatures that do not closely resemble the human form usually share some of the basic anatomical characteristics.

58

DRAWING

It is not necessary to know every bone and muscle, but it is useful to recognize the parts that significantly influence the shape of the body. The skull, chest, hips, and four sections that make up the arms and legs are the areas that receive most attention when developing a fantasy character. The size or proportions of these anatomical elements can make the difference between a heroic woodsman and a troll, graceful princess or evil hag.

The skull
Visualizing the skull from different angles helps when creating the imaginary version. It is important to retain as much of the normal form as possible at first, and then exaggerate certain elements.

The feet
Exaggerating feet can be an effective way of turning a normal-looking character into one from the world of fantasy. The desired effect can be achieved by using an anatomically correct version, then lengthening parts, or making the joints more obvious. Use your own feet as models, and then exaggerate the basic drawings.

The bones beneath
Some knowledge of the skeleton is helpful, though not essential, when deciding on poses and positions for your characters.

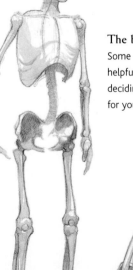

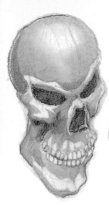

Cheekbones, jaw, and mouth
are much enlarged.

The head is elongated and the jaw
is jutting outward.

The whole skull seemingly pulled
downward, and eye sockets tilting
up at the edges.

Function of hands

When drawing hands with a view to
exaggerating or distorting them, remember
that they must always be capable of
performing their functions of gripping
objects, hitting, lifting, and so on.

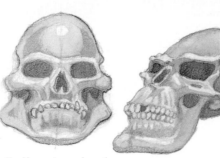

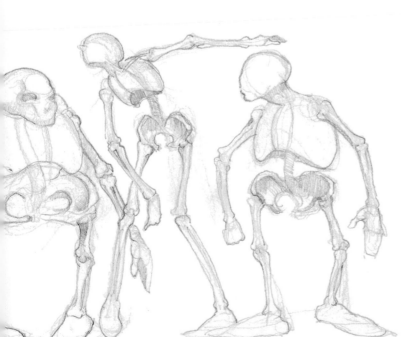

Abbreviated anatomy

The best way to visualize these sections is by
drawing stick figures, or what I like to refer to
as "abbreviated anatomy." These figures allow
the artist to determine the proportions and pose
of a character quickly, with little effort, before
considering geometric shapes. By using lines to
represent the major bones, an oval for a head, a
box or cylinder for a chest, and a cone for the hips,
a character can be "roughed out" to determine its
proportions, including overall size, stance, and
any action or movement. Many sketches can be
roughed out quickly using this method, giving the
artist a number of options from which to start work.

Body shapes

Once the proportions and pose have been
determined using the stick figures, the artist
needs to know a little more about the anatomy
of the body. The human form is widely used in
fantasy art. If the character is intended to resemble
a human in any way, it is best to follow the basic
shapes and functions of the bones and muscles that
make up a body. Similarly, if the fantasy subject is
a four-legged creature, or other type of animal,
it is a good idea to study the basic anatomy of a
living creature that closely resembles the fantasy
form. The pages on Imaginary Beasts (pages 62–65)
show how animal forms can be developed into
fantasy creatures.

Personality and appearance

The type—personality—of the character influences
its appearance—for example, in terms of the size
of body parts and the way they are linked. The size
and position of the head on the chest, or the length
of the bones in the arms and legs depend upon the
fantasy persona. Will it stand perfectly erect or
will it be hunched over, dragging its long arms just
above the ground? Will it be athletic, running on its
long legs, and throwing its long arms out in front of
it? Perhaps it will be short and plump, and appear
to be too slow to move at all. The bone and muscle
structures contribute to the right impression. By
sketching and adapting abbreviated drawings (or
stick figures) of the normal anatomy of a similar
species, it is possible to decide what must be
exaggerated or changed.

Artistic license

Once you know how the skeleton structure
works, you can make alterations to the basic
bone structure, but it must still be believable
in terms of function.

ANATOMY
PRIMER

Movement

The artist has to be restrained when exploring movement in figures, and overcome the natural inclination to want to see the end result as soon as possible. Rushing to the finished stage can lead to problems that are best worked out by sketching lines and repositioning simple shapes.

When figures are sketched in simple geometric shapes and lines, it is easy and quicker to alter different aspects of the form than when working with three-dimensional drawings. For example, obviously, it is much easier to lengthen or shorten a single line than to rework a finished drawing of an arm or leg. When one body part is adapted, others can be amended to retain—or exaggerate —proportions, as necessary to create the fantasy character.

60

DRAWING

Capturing moments of action and movement

The stance of the character can be drawn by translating the anatomy into basic shapes for the head, chest, and hips. Then lines of the correct length are added for arms and legs. Even the curvature of the spine can be determined using this technique. It is easier to illustrate figure movement realistically by this simple method. Fantasy art usually does more than illustrate one scene, or one point in time, because it tells a story, and therefore it is often necessary to show a character in action. By sketching the abbreviated (stick-figure) version in the proper pose, the details of the character can be built with confidence on the correct foundation. Using this technique, it is possible to make decisions about altering sections of the figure, adapting areas of the artwork to create the impression of fast movement. Working with simple shapes and lines allows the artist to explore many options before deciding to work up the finished piece.

Building from the first shapes
The figure can be adapted to an apelike stance, have a pudgy build, or elongated body. If a moment of movement or action can be captured by using simple shapes and lines, drawing the finished art is easier and the result is more likely to be correct.

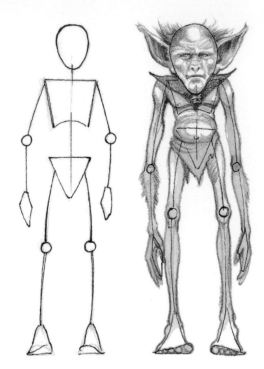

Exploring movement with simple shapes
Sometimes it is easier to create an exaggerated character by starting with an anatomically correct figure. The easiest way of making decisions about the character, and its pose, is to sketch the model in lines and simple shapes, and then adjust sections to exaggerate different aspects. The sketches shown below are examples of an exploration of movement.

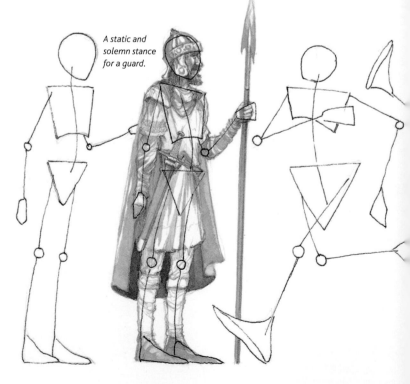

A static and solemn stance for a guard.

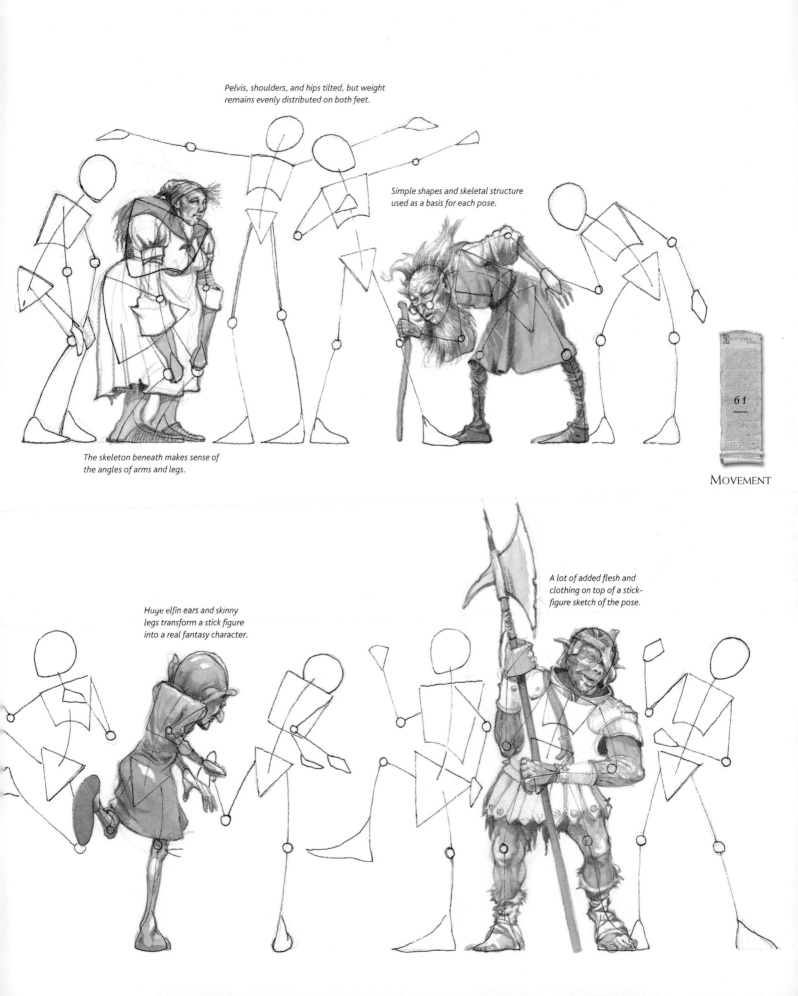

Pelvis, shoulders, and hips tilted, but weight remains evenly distributed on both feet.

Simple shapes and skeletal structure used as a basis for each pose.

The skeleton beneath makes sense of the angles of arms and legs.

Huge elfin ears and skinny legs transform a stick figure into a real fantasy character.

A lot of added flesh and clothing on top of a stick-figure sketch of the pose.

MOVEMENT

Imaginary Beasts

Beasts of every shape and form play a significant role in fantasy art. They are sometimes the characters that most clearly define the art as a fantasy work. For the artists, the skill is in combining characteristics of different species, adding details that are not normal by nature, and exaggerating the size of creatures in proportion to buildings and other objects.

References from wildlife
A combination of the traits of human, monkey, buffalo, and bull species are used to produce the art below. A good file of wildlife photographs provides the artist with reference material from which to select and draw characteristics of different species.

Main characteristics
The armored rider has a recognizable monkey face, and his mount is based on a mixure of a buffalo and a bull, but with the addition of unicornlike horns and elongated ears. Both are entirely believable in terms of anatomy and posture.

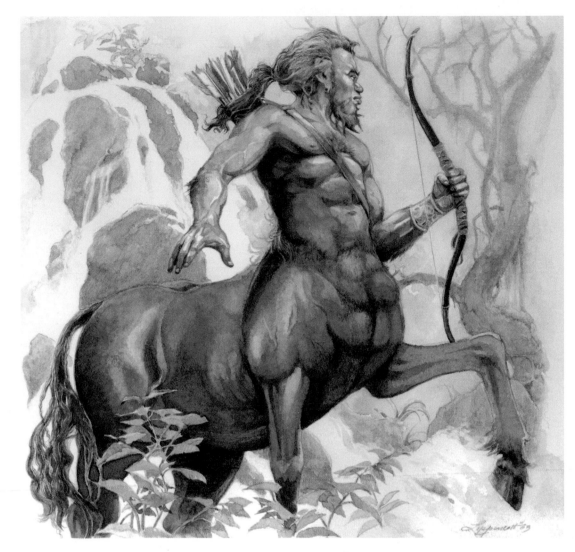

Crossing species

The centaur is an obvious molding of human and animal features. The separate parts of both man and horse are drawn very realistically to give this piece a true feeling of fantasy.

As varied as fantasy creatures are, there are a few basic categories into which they all seem to fit. There are those derived from a combination of characteristics of two or more animals. Most dragons, in general, seem to be the product of serpents or lizards, crossed with the wings of a bat. Griffins are a mixture of traits from the lion and eagle. More imaginative beasts can be created by combining the anatomies of goats, buffalos, apes, and dogs.

The creature becomes convincing when the artist pays close attention to the prominent characteristics of each animal's anatomy. The hide or skin of one animal may be used on the form of a completely different species. Details, such as horns, tails, and hooves, drawn on animals that would not have them in nature can impart the sense of fantasy.

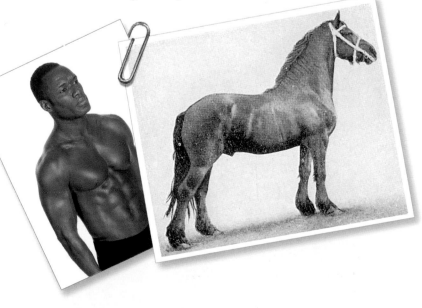

Humans and animals

Another category of fantasy creature combines human traits with animal characteristics. There are a great number of characters derived from the human/ape combination. Trolls, abominable snowmen, and some giants are products of this genre. Some of the best-known man–beast crosses include the centaur (see page 63), the man with the body of a horse, and the Satyr, a combination of goat and man. Learning the basic anatomies of the animal world will help the artist morph beast and man in a very natural way.

Monstrous size

Abnormal size is another feature by which fantasy creatures can be categorized. Spiders the size of buildings, mice harnessed for pulling transport, and sea creatures large enough to swallow a ship have all featured in fantasy art.

64

DRAWING

A running posture could be read as aggression, providing ideas for a combined human–animal treatment.

Animal anatomy

By looking closely at the natural structure of animals, the artist can build up a convincing beast without a model. The dragon can be created by using pictures of lizards, alligators, snakes, and bats. For success, be selective and use exaggeration sparingly.

A similar posture, but now with human characteristics, including the removal of body hair.

Man and beast

The combination of human and animal form make good fantasy art subjects. Studying the stance of a gorilla, and blending it with a more human character, produces a convincing troll.

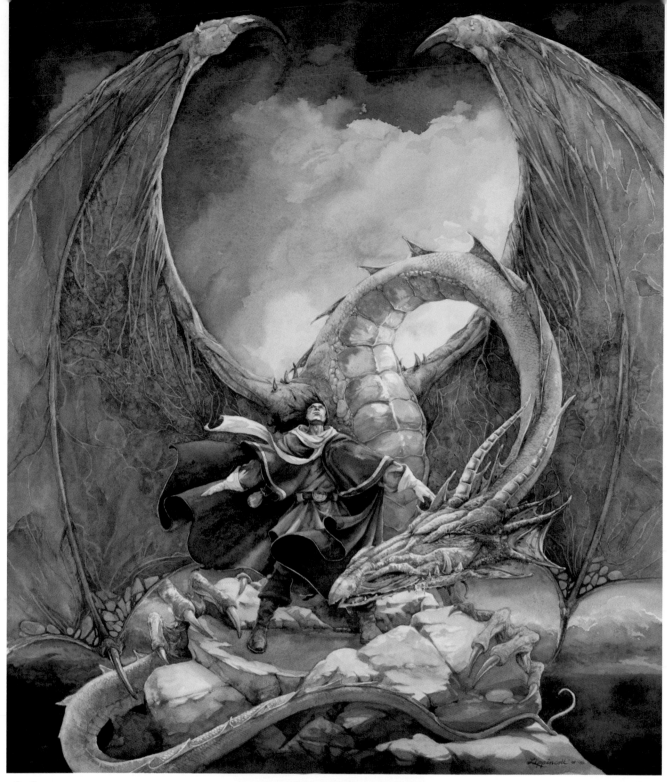

65

IMAGINARY
BEASTSIMAGINARY
BEASTS

❧❧ THE OTHER WIND
by Gary A. Lippincott

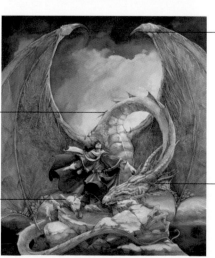

Birds' beaks surmount the dragon's wings to give an extra sense of menace.

Scaly skin, and spikes along the neck and tail, both common features of dragons, can be seen in real creatures such as iguanas.

Huge and terrifying claws, vastly larger than the hands of the dragon's intended victim.

The dragon's head is a composite of snakes, lizards, and root forms, with the horns based on a goat.

1 Simple to sophisticated
Even the fairly simple stance of this character was established by determining the pose in lines before working up a realistic drawing. It was helpful to check the length of arms and legs, the direction the head was facing, and the overall stance and posture of the character before drawing the anatomy.

developing Sophisticated Drawings

It may be hard for the artist to fight off the temptation to forge ahead with the finished artwork, but a lot of time is spent wisely by going through the slower process of building up figures and forms.

There's nothing quite so disappointing as noticing a problem on a beautiful, highly detailed drawing when it is finished. For example, one of the arms may seem longer than the other, or the head of the character may be turned slightly upward, but the mouth seems to be facing outward, to the person looking at the page. It is best to work out problems with the drawing before spending lots of time and energy on finishing the artwork. Sometimes, it also helps to work up detail drawings off to the side of the paper, or elsewhere, to figure out how something should look before adding it to the finished art.

Foundation drawing

It is important to start with the simplicity of a gesture drawing, or stick figure, and gradually add the three-dimensional structure of the anatomy on top of it. Building up the simple geometric drawing in this way forms the foundation that must be in place to ensure that the more sophisticated work is correct in its placement and perspective. This is the best way of ensuring that intricate details are added in the right places to create the illusion of reality.

2 Anatomical outline
Once the gesture drawing seemed correct, sketching the three-dimensional anatomical outline in the correct position was much easier. It was helpful to have the basic anatomical structure in place when the time came to drape the costume over the figure.

3 Building up layers
The artist always has to remember that the aim is to make the two-dimensional drawing appear to be three-dimensional. By using this "x-ray vision" method of building up layers, leaving the structure visible underneath, the end result is more likely to look realistic.

Simple shapes for stance and perspective

To avoid introducing mistakes later, keep the drawing simple at first. Get the pose right. Make sure the positions of the head, arms, spine, and legs are correct before moving on. Get the proportions and perspective correct before the drawing is complicated, or the outline confused, by a lot of intricate detail. Save the costume and details for last, when all the body parts seem to be in place.

You may need to make separate studies of costume details.

Establish the pose by marking in vital joints such as knees and elbows, and sketch in main lines of movement.

Once the pose is satisfactory, clothes and facial details can be added.

Hands and feet are both hard to draw, so again make separate studies before finalizing the figure.

The curve of the hat plays an important part in defining the shape of the head, and the shadow helps to show up the features.

67

DEVELOPING
SOPHISTICATED
DRAWINGS

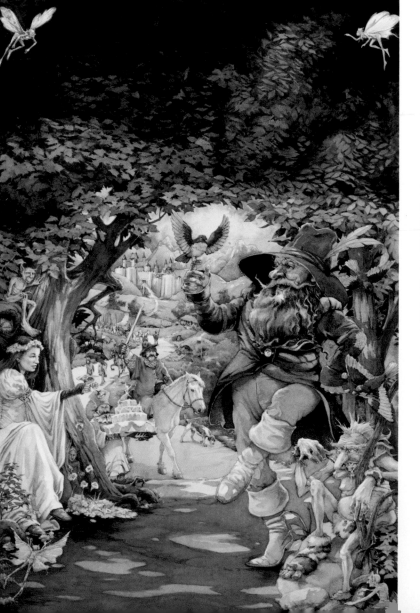

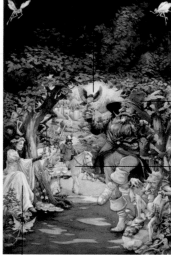

The bird is framed by the light area of sky, which in turn highlights the pinnacled castle.

The solid modeling, strong tonal contrasts, and eye-catching red hat ensure that the "hat guy" is the main center of attention.

The white horse echoes the white of the fairy queen's clothing and the pale semicircle of sky, making links between the different areas of the picture.

For a finished work, composition is all-important, and the fairy figure is placed so that she does not draw attention away from the main figure.

A TOLKIEN MISCELLANY
by Gary A. Lippincott

Costumes

Fantasy art is almost always narrative in nature; therefore it is important that it contributes clues and character to the story. The clothing worn by the characters will impart a very good sense of the nature of the story. Sometimes the costumes alone indicate that the scene is a fantasy, without the need for the abnormal characters.

DRAWING

Fantasy writing often seems to be set in a world resembling Medieval and Renaissance times, so it is a good idea to study the styles of dress of these periods. The elaborate costumes of kings and queens, princes and princesses, pages, knights, bards, and other typical characters, are great sources of inspiration for dressing fantasy characters. By starting with historically accurate costumes, and adding imaginative elements, such as dangling bells, large cuffs, or sections made of natural materials (leaves, flowers, or twigs), individual characters can have their own fantasy wardrobes.

Cloth study

It is a good idea to learn how to draw cloth well. First, study plain cloth, with no design on it. Drape a piece over objects that might resemble various parts of the anatomy. The Old Masters painted beautiful studies of drapery, and their work is an excellent source of reference. Once you have practiced drawing plain cloth, try sketching fabric with printed or woven designs. Start off with simple designs that translate well over folds and creases—large circles and lines are good for highlighting folds and drapes. Practicing this exercise is a good way of becoming proficient at drawing very realistic-looking costumes.

The whipped-cream hairstyle is an exaggeration of the "big hair" fashionable in the 18th century.

The skinny legs with disproportionately large feet, as well as the curling coat-tails, denote a fantasy wardrobe, although based on real fashions.

The bells on the hat are reminiscent of Elizabethan court jesters, and the man's costume is oriental in flavor.

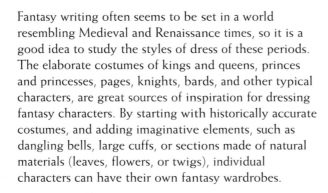

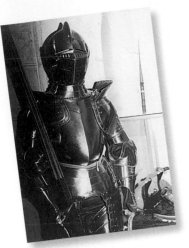

Adaptable armor
A suit of armor provides features that can be used on fantasy costumes, including the helmet, breast plate, and gauntlet gloves.

Items such as boots, swords, and suits of armor can be seen and studied in military museums.

Functional costumes

Sometimes the costumes are functional. Fantasy writings are full of adventure stories, in which the characters travel to distant lands, through all types of weather, and the costumes should be appropriate for the journey or activity. Capes with hoods, large hats, walking sticks, and similar, are useful accessories to help tell the story. As when designing the characters themselves, it usually helps to exaggerate features of the costumes—feathers that are larger than life, enormous boots, and beautiful designs are a few elements that can give characters a convincing fantasy appearance.

Costumes for travel
A functional costume for travel would include a large hat for protection from the sun and rain, a cape for bundling around the character in bad weather, a large bag with a shoulder strap to carry food and supplies, well-built footwear, and, of course, the walking stick.

Both costumes have roots in reality or legend, but the queen's headdress is impossibly tall, and the peasant's footwear might be hard to walk on.

There is nothing strange about the monk's robe itself, but his large pointed ears and long feet take him into the world of fantasy.

The costumes for these dancing players are taken from a variety of sources, and their instruments are those we still know today.

Depth and Perspective

Perspective drawing is one of the fundamental skills for any artist. Being able to draw objects that appear to foreshorten into the distance is essential for making anything, and everything, appear realistic—buildings, landscapes, interiors, and figures.

Standing in the middle of a straight highway and looking ahead to the horizon, you will see that all the lines of the scene converge at the same spot. In perspective drawing, this is called the vanishing point *(VP)*. The vanishing point is always on the horizon line but is not fixed and is not always a single point. The number of points and where they are placed is determined by the subjects and the position from which they are viewed, known as the viewpoint. The viewpoint is the direction from which the artist views a scene and can vary from straight ahead to any angle. The horizon line *(HL)* is also known as the eye line, because it represents the height at which the scene is viewed and this is always at the artist's eye level.

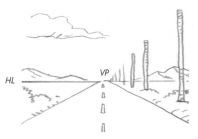

The visual lines of this scene all meet at the vanishing point, including those of the central highway and the top and bottom of the poles on the right.

One-point perspective

When both the viewer and the object viewed are on parallel planes you can only see one side of the object and there will only be one vanishing point, so this type of perspective drawing is called one-point perspective.

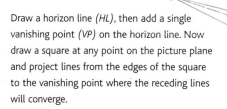

Draw a horizon line *(HL)*, then add a single vanishing point *(VP)* on the horizon line. Now draw a square at any point on the picture plane and project lines from the edges of the square to the vanishing point where the receding lines will converge.

To construct a cube in perspective, draw a square on the picture plane parallel to the horizon line and project lines from each corner to a vanishing point. Choose a point along one projected line and draw another square, bounded by the projected lines. This forms the back surface of your cube. Here the lines have been drawn downward from the vanishing point so that we appear to be looking down on the cube from a bird's-eye viewpoint.

If we do the same exercise, but draw above the horizon line, the cube appears to be above us. We have the impression that we are looking up at anything drawn above the horizon line from a worm's-eye view.

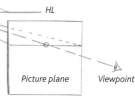

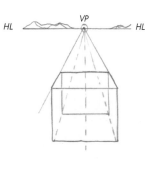

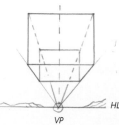

Two-point perspective

When an object is viewed from an angle there will be one edge or corner that is closer to the viewer; this is called the leading edge. Both sides of the object that recede from this leading edge will have their own vanishing points. This type of perspective drawing is called two-point perspective.

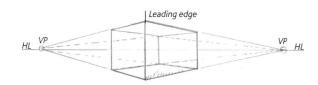

To construct a box in two-point perspective, draw the horizon line and add two vanishing points anywhere along it. Project lines outward from the vanishing points and where they meet on the picture plane will be the leading edge. Add vertical parallel lines to construct a box. In this example, the viewpoint is at the same level as the horizon line, so the box appears to be at the same eye level as the viewer.

As with one-point perspective, drawing above or below the horizon line changes the apparent viewpoint. Using two viewpoints together gives the impression that one object is flying over the other.

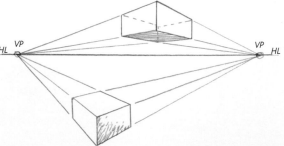

Interiors

To construct an interior use two-point perspective
—this may be a room, cavern, or any similar space.

Drawing the perspective framework

Draw the horizon line and two vanishing points.
Then draw a series of lines projecting from
these points, above and below the horizon line.
To draw these lines, put your pencil on the
vanishing point and slide the ruler up to it.
Draw the line, then put your pencil back onto
the vanishing point before moving your ruler up
or down to the position for the next line.

Constructing the room

Draw in one vertical line to form the far corner
of the room or space. Next, take your ruler and
line up the top point of the vertical line with
each of the vanishing points. By drawing
outward from the top of the vertical line, you
can create the top horizontal lines of the walls.
Do the same at the bottom of the vertical line
for the edges of the floor.

Adding a central object

To create the basic shape for a table in the
room start with a single vertical line and project
lines toward the vanishing points from the top
and bottom of this vertical line. These lines
form the top and bottom of the table. Choose
where the other vertical lines will go. Their size
will be dictated by the perspective lines you
have just drawn from the first vertical line.

Adding pillars and furniture

Use the same basic process to add pillars and
furniture. The chairs are based on the basic cube
shape, and their lines match up with either of
the vanishing points. For variation, you can cut
into the basic cube shape to make the table
a hexagon. This can be quite difficult to begin
with, so you will need to practice.

Adding detail

Add arches and a gallery at the top of the wall
using the same method. Make sure your vertical
lines are all parallel; otherwise the drawing will
start to look askew. Be warned. This can be
incredibly frustrating, but it is essential to learn
this skill. No artist can get by without it.

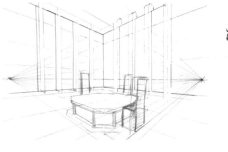

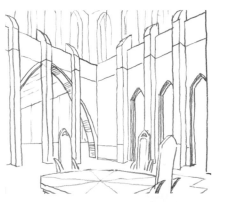

Figures

The artist may use perspective lines
to draw figures. A basic grid can be
used as a rough guide for drawing a
figure. The lines of the figure do not
have to match up perfectly with the
vanishing points, but following the
grid fairly closely will help to give
the figure a more dynamic pose.
This method is particularly useful
when the drawing creates an illusion
of looking up or down at a figure.

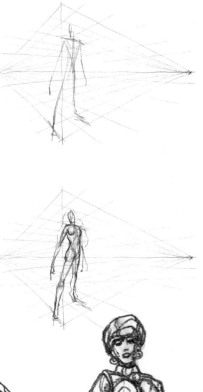

DEPTH
AND
PERSPECTIVE

Chapter 3

TECHNIQUES

The techniques of fantasy
illustration rely on some essential
skills quite apart from an innate
imagination. These skills are used
and understood by all artists, but
executed in different ways
according to the requirements of
their specialty subject.

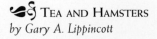

TEA AND HAMSTERS
by Gary A. Lippincott

Design and Layout

Once you have a clear idea about the content of your picture, you need to decide on the overall composition. It is best to do this by making a series of small sketches. There are different kinds of composition, as shown in the examples of basic frameworks below; but the two primary aims are, first, drawing attention to the main subject and, second, arranging the other elements in such a way that produces a sense of harmony, rhythm, and balance.

Vertical and horizontal
In this arrangement, the main center of interest is placed in the central vertical, with extra information and detail in the top horizontal bar.

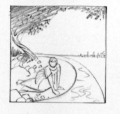

Zigzag
This arrangement, with the main interest at the front, is especially good for landscape subjects, as it produces a strong sense of rhythm.

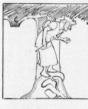

Emphasis at side
This is based on a C shape, with the main interest dominating the left side of the picture and extending along the bottom and top.

Emphasis at side to center
In this reversed C-shape framework, the main subject is at the right, with the pole providing a strong vertical slightly off center.

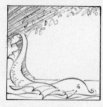

Dividing the picture plane
In this framework, the vertical and horizontal cross divide the page roughly into one third and two thirds. The eye is drawn to elements placed at the intersection.

Transferring drawings

Having made a number of sketches and established a satisfactory composition, the next step is to transfer the information onto your working surface, which will sometimes be larger than the sketch. If you want to enlarge the sketch first to make the process easier, you can do this on almost any photocopying machine.

Working freehand

If your sketch is the same size as the finished image is to be, simply draw a grid over each, and transfer the information from sketch to working surface. You can work without the grid, but it is easy to make mistakes.

Tracing off

For this method also, the sketch and final image must be the same size. Make a tracing of the sketch, turn it over and scribble over the lines with a soft pencil, then place it right side up over the working surface and go over all the lines with a sharp pencil.

Squaring up

This is a method for enlarging a drawing. Draw a grid over the sketch, and then draw a larger one on the paper. To make the drawing twice the size you would use a ½-inch grid on the sketch and a 1-inch grid on the paper. Transfer the information carefully from each small square to the corresponding larger one, paying attention to where each line intersects a grid line.

Firm grip

You need to make precise lines when transferring drawings, so hold the pencil firmly near the lead end, which gives the maximum control.

Pencil drawing

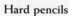

The pencil can be used in any number of ways, and to create further variations different grades of pencil—hard, medium, and soft—can be combined in one drawing. Conté pencils and crayons are useful for broader effects.

Hard pencils
A 2H pencil, which is in the hard range, gives fine, quite faint lines, does not smudge, and is ideal for delicate areas such as wings.

Medium and soft pencils
HB pencils (medium) can create both sharp lines and areas of light tone achieved by shading. Use a softer pencil such as a 2B for darker tones.

Conté crayons
These can be used on their side for broad textured areas. Conté is also available in pencil form for more linear work.

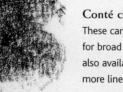

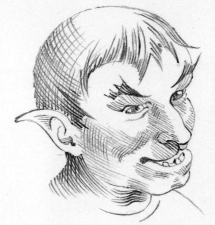

Tonal gradation

Tones are gradually built up in this image, working from a very light tone and slowly getting darker in the appropriate areas by sometimes switching to another grade of pencil. The direction of the pencil strokes follow the contours of the subject matter.

Hatching and crosshatching

With hard-to-medium pencils, tones are built up by hatching and crosshatching. The lines can be straight, or curved to follow the form, a technique sometimes known as bracelet shading.

Shading

The same methods can be used with softer pencils, but in this case the lines will tend to merge together to give more solid shading. Increase the pressure on the pencil for darker areas.

Smudging

Hatching lines made with soft pencils or conté can be smudged with a finger to soften and spread them out. Here conté has been worked quite solidly on the dark side of the tree and smudged toward the middle, so that one tone merges gently into another.

drawing Ink Lines

Pen and ink is one of the oldest of all drawing methods, with quill pens—still popular with today's artists—being used long before the pencil was invented. Nowadays there are many different drawing pens available, from traditional bamboo, quill, and dip pens to those with their own reservoirs of ink.

Varying the lines
Quill pens allow you to vary the lines from thick to thin and to taper each stroke by varying the pressure.

Open hatching
To build up tones or to suggest texture, loose, free hatching, and crosshatching lines can be used.

Scribbling
Scribbled pen lines of different weights are very effective in areas where precision is not required.

Inks
A wide range of drawing inks is now available in many colors other than the traditional black. Some are waterproof and others water soluble. The latter can be washed over with water to provide middle tones.

Forms and edges
Curved, open hatching lines on the left, made with a quill pen, contrast with tighter crosshatching on the right to differentiate the two forms and define where they meet.

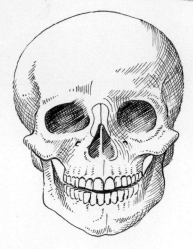

Form-following lines

Hatching and crosshatching lines can be varied as the subject demands. Here, close diagonal hatching lines are used for the eye sockets, while curving crosshatched lines follow the rounded forms at the top of the skull.

Combining pens

Here, two pens, a rapidograph and a dip pen, have been used together. The former produces fine, uniform lines, while the latter gives heavier and more varied ones.

Delicate lines

Dip pens have interchangeable nibs, with the finer ones being best for delicate effects.

Varying pressure

Varying the pressure on the pen and the angle at which it is held allows for both heavy and light line work.

Stippling

This is another traditional method for building up form in pen-and-ink drawings. It is slower than other forms of shading, but creates lovely effects.

Bold lines

A larger nib can be used for heavier, more robust lines. Notice how some of the lines are "broken" to avoid too much uniformity.

Mixed methods

Here, brushwork has been combined with pen line and stipple, with fine white lines created by scratching into areas of solid black.

starting to Paint

Once you begin to use color, a whole new world will open up. You may find it difficult at first, and you will certainly make mistakes, so begin by simply trying out your paints to get the feel of them before starting on an actual painting.

Mixing colors

The first thing you will have to learn is how to mix colors to achieve the hue you want; but avoid mixing more than two or three colors together, or you will end up with a mud-colored mixture. Paints can be mixed in the wells of the paint box, as shown here, but you can also buy separate palettes or improvise your own—old plates or saucers are quite adequate.

Laying flat washes

In watercolor work, it is usual to begin with washes, which can be defined as areas of color broader than those that could be achieved with a single brushstroke. Practicing laying flat washes is a useful exercise, as it helps you to familiarize yourself with the tools of the trade—paints, brushes, and paper. Flat washes can be laid on wet or dry paper; here the paper has been dampened to make the paint flow more easily.

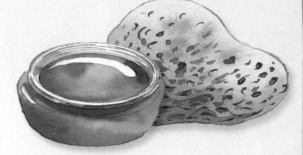

1 Mix up a large amount of paint—you always need more than you think—and then dampen the paper all over with either a large brush or a sponge.

2 Load the brush full of color, and sweep it over the paper from left to right (or right to left if you are lefthanded), starting at the top.

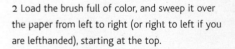

3 Lay the next stroke so that it just touches the bottom of the first one, and continue the process until you have reached the bottom of the paper.

The finished wash provides the perfect backdrop for your pencil drawings.

Surface mixing

This is the term used for mixing colors on the paper rather than in the paint box or palette. Washes can be graded from one color to another, or from a color to white, and new hues can be made by laying one patch of color over another; blue laid on top of yellow, for example, will produce green.

True blue

Amber yellow

Two-color wash

To paint a wash containing two or more hues, first mix the colors separately, dampen the paper, and lay on the first color as described on page 81. Wash the brush and then lay the second color, picking up the first one with the initial stroke. Where the two colors overlap and mix, a third color will be created.

Phthalo blue with a touch of green-gold and magenta

Graded two-color wash

More subtle effects can result from using two closely related colors, such as green and blue of a similar tone, which will merge unobtrusively into one another. Here, the wash has been graded from a mid-tone at the top to almost white at the bottom by progressively adding more water to each band of color.

Keeping colors separate

A brushstroke or wash of watercolor will always stop when it meets dry paper, so to keep each new color from mixing into its neighbor allow the first one to dry fully first.

True blue

Ice green *Permanent magenta*

Color overlays

If you want to mix two or more colors on the paper in a controlled manner, again let each one dry before overlapping a second or third color. Laying yellow over blue or vice versa will produce green, while the yellow modifies the red to give an orange tint.

Permanent yellow

Phthalo blue

Permanent red

Permanent yellow

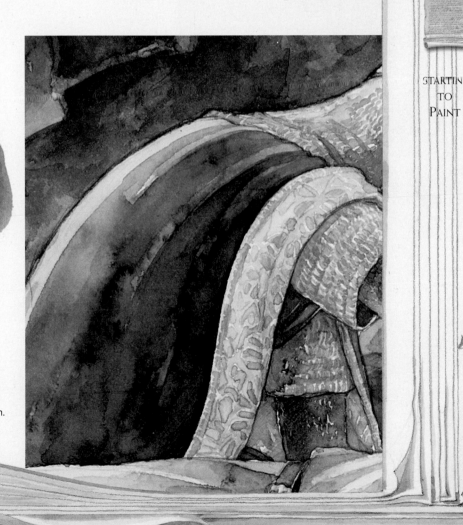

Phthalo blue *Permanent red*

Wet-in-wet

Colors will mix in a more random way when each one is still wet, as each one spreads out with uneven, jagged edges rather than hard lines. Wet-in-wet color mixing is slightly unpredictable but can be very effective. This detail from Anke Eissmann's watercolor painting on page 107 shows the use of wet-in-wet mixing to convey the fabric of a cloak—successfully creating a sombre sense of mood and emotion.

Highlights and Shadows

❧❧❧❧

The way you treat the darkest and lightest areas of a subject depends on whether you are working in color or monochrome. In a drawing, highlights can often be rendered as pure white, and shadows as gray or near black, but in fact both highlights and shadows, especially the latter, are often subtly colored.

Toned paper
In a drawing such as this study in brown and white conté, it is helpful to work on a mid-toned paper so that you can work up to the highlights and down to the shadows.

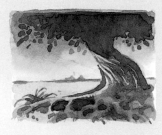

Shadow colors
Bold purple–blues have been used for the mass of the shaded tree, while the shadows in front are warmer in color to make them come forward in space.

Smudging
Charcoal or conté can be smudged for soft shadows, leaving white paper for the highlights.

Cloud shadows
The undersides of clouds form shadows that pick up a wealth of colors reflected from the sky, sun, and water or land beneath.

Leaving white paper
In watercolor work, the brightest highlights can be reserved as white paper, and the shadows built up by loosely overlaying blues, reds, and light greens over flesh pink.

Opaque highlights
With gouache (opaque watercolor) or acrylic, the main color can be painted first, and white added for the highlights.

Changing colors
The shadows and highlights on stone buildings vary according to the prevailing light. In an evening light the highlights may be golden, while the shadows may be bold reds and blues.

Shadows on green
Shadows on green leaves or grass are often blue or purple rather than simply a darker shade of green.

Using masking fluid
Painting on masking fluid, which is removed when the paint is dry, is an excellent way of reserving small, intricately shaped highlights. The white areas can be tinted if they appear too bright when the work is almost complete.

Pencil shading
Pencil can be combined with watercolor washes to build up the shadows on a regular form such as this metal pipe.

Tone and Color

Creating a good balance of light, dark, and middle tones is just as important in a painting as it is in a drawing. In watercolor work, you always work from light to dark, building up depth of tone gradually, but you should have a clear idea of where the darkest tones are to be from the outset, so that you can place them boldly, without overworking.

Hidden worlds
By keeping the palette of this illustration limited to blues and browns, it takes on the cool, dank atmosphere of the undergrowth. Using such a palette in the foreground makes for a clever separation of "worlds"—between the fantasy foreground and the rest of the illustration.

Building up tone and color

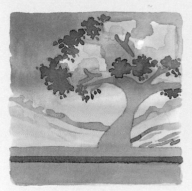

1 First wash
Yellow is naturally lighter in tone than most other colors, so begin by laying a yellow wash over the landscape and parts of the tree.

2 Second wash
When the paper is almost but not quite dry, lay a blue wash over the sky and part of the tree, overlapping the edges of the yellow areas.

3 Overlaying colors
Mid-toned browns can now be laid over the blue and yellow for the tree trunk and branches, foreground, and shadows on the distant hills. Use a deeper blue mixed with brown for the shaded clumps of foliage.

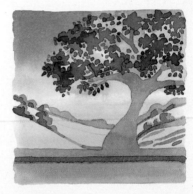

5 Finishing touches
Now add small touches of really dark tone to the foliage and background bushes, using the tip of the brush. Finally, build up the form and texture of the trunk using the same dark tone and making long, sweeping strokes that follow the direction of the leaning tree.

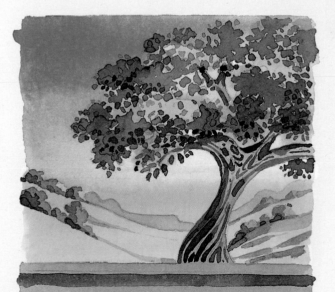

4 Adding detail
Continue to add darker tones to the foliage, leaving patches of yellow for the bright highlights. Paint the background brushes with green and, when dry, add shadows using the same color as for the tree foliage.

Amber yellow *True blue* *Hyacinth blue*

Color palette
These are the three main colors used in this painting, they can be mixed together to create the greens and browns.

Texture and Paint Effects

∞

The actual textures of objects, such as of tree bark or grasses, can be imitated in a number of ways, but you can also create more interest in a painting simply through the way you use the paint. Attractive effects can be achieved by mixing colors wet-in-wet, or encouraging the paint to granulate, thus enlivening flat areas such as skies.

TECHNIQUES

Relative wetness

Success with wet-in-wet methods relies on the ability to judge the wetness of the paper. If the paper is too wet, the colors will not remain distinct, as shown above.

Color blends

If you wait until the sheen is off the paper, but is still relatively wet, each band of color will run into its neighbor, as shown here. You can control the flow of paint by tilting the board in a chosen direction.

Selective wet-in-wet

If you wish to blend colors wet-in-wet in just one part of a picture, wet the paper only in this area. The paint will not flow outward onto dry paper.

Drop in the first color and then add others, letting them flow along the shape.

A slight variety of color can be used to add interest and depth and to prevent the area from looking lifeless.

To create subtle color variations for subjects such as foliage, first wet the entire image area. Drop in yellow to begin with for the lighter areas.

Add blue and green toward the mid-tones or for different leaves.

Add a darker color for more shaded areas of different leaves for variety and vibrance.

TEXTURE
AND
PAINT EFFECTS

Just add water

To make a sky more interesting and lively, lay blue on wet paper and add more water toward the bottom. The watery paint will flow upward into the darker color.

Granulation

Some colors cannot be fully "melted" by water; small particles remain so that the paint dries with a granular effect. Here, two granulating colors have been worked wet-in-wet.

Techniques

Watercolor and acrylic

Since both these paints are water soluble, they can be used together by mixing or by laying one over another.

Salt in paint

Salt can be sprinkled over or mixed in with paint to create intriguing but unspecific textures. This example shows a mixture of gouache, watercolor, and salt.

Watercolor pencils

These pencils can be used on their own or combined with watercolor to create texture in part of a picture. At bottom right, the pencil has been washed over with water to create a textured wash.

Mixed methods

In this painting a number of techniques have been used. The blue for the sky has granulated slightly (**1**), and the cloud on the right has been worked wet-in-wet (**2**). Some of the colors on the horse have also been worked wet-in-wet (**3**), salt has been mixed with paint for the foreground washes (**4**), and the grasses have been drawn in with watercolor pencil (**5**).

Color Mixes

❧

Color mixing is mainly learned through experience, but it is helpful to have some idea where to begin, or you may waste a lot of paint and time trying out mixes. Here you will find suggestions for five subjects that may form elements of your paintings, and the following pages give some hints for skin tones.

Laying flat washes

Permanent yellow	*Bright red (or cadmium red)*	*Permanent magenta*	*Green–gold*	*Phthalo blue*	*Prussian blue*	*Ivory black*

Gray/silver metal

Phthalo blue with a touch of both green–gold and magenta

Prussian blue with a touch of green–gold and magenta

Brass and gold

Permanent yellow with a little green–gold and bright red. Yellow alone for highlights

Green–gold with a touch of bright red and Prussian blue

Stone

Ivory black (the best black for mixing with other colors)

Ivory black and green–gold

White fabric

Prussian blue with a touch
of magenta

Ivory black with a touch of
green–gold

Leaves

Green–gold for highlights

Green–gold with a touch of
Prussian blue

Prussian blue with a touch of
green–gold and magenta

Prussian blue with a little
green–gold and magenta

Colors for a bronze sword hilt

This has been done in acrylic, used thinly in "watercolor mode,"
but a similar effect can be achieved with watercolor, using
a little acrylic or gouache white for the highlights.

1 Wash greens, lilacs, blues, and reds over shaded areas,
and allow to dry.

2 Wash yellows loosely over the lighter parts of the metal,
allowing the color to overlap the shaded areas in places.

3 Leave to dry, then put in the darkest shadow details with
mixes of purple and blue to make maroon hues.

4 Add red for the shadow
areas along the edges,
which reflect the rich
metal color.

5 Finally, add highlights with white, softening the edges
with a damp brush as needed.

Colors for Skin Tones

Skin tones vary widely, depending on the person's ethnic group, age, and occupation. Start by trying to establish the base color, which may be pinkish, ivory, or slightly yellow in the case of Caucasians, and a range from yellow–brown to purplish–brown in the case of Asian and Afro–Caribbean skins. The palettes shown here are for watercolor, acrylic, and watercolor pencil.

TECHNIQUES

Watercolor or acrylic palette

Permanent yellow	*Yellow ochre*	*Permanent red*	*Brilliant red*	*Crimson*	*Green–gold*

Light green	*Phthalo blue*	*Blue lake*	*Prussian blue*	*Light red*	*Transparent brown*

Bronze yellow	*Magenta*	*Permanent violet*

Watercolor pencil palette

Lime peel	*Jade green*	*Sienna brown*	*Imperial violet*	*Lilac*	*Poppy red*

Peach	*Blush pink*	*Deco pink*	*Yellow ochre*	*Dark green*	*Light umber*

Caucasian skins: watercolor

Base colors

Small amount of permanent red, with touches of green–gold, crimson, and Prussian blue

Permanent red, with touches of permanent yellow and Prussian blue

Permanent red, with a touch of crimson and green–gold

Shadow colors

Crimson with touches of blue lake and Prussian blue

Prussian blue, permanent red, and a touch of green–gold

Caucasian skins: acrylic

Base colors

Brilliant red with a touch of light green

Yellow ochre with a touch of brilliant red

Yellow ochre and blue lake

Shadow colors

Brilliant red with a touch of light green

Blue lake with touches of crimson and brilliant red

Caucasian skins: watercolor pencil

Base colors

Yellow ochre and blush pink

Yellow ochre and peach

Rose deco and poppy red

Shadow colors

Jade green, peach, and lilac

Lime peel, deco pink, and jade green

Afro–Caribbean skins: watercolor

Base colors

Permanent red and phthalo blue

Permanent red with touches of Prussian blue and green–gold

Light red with a touch of phthalo blue

Shadow colors

Prussian blue and light red

Prussian blue and light red with a touch of magenta

Afro–Caribbean skins: acrylic

Base colors

Blue lake and brilliant red

Yellow ochre, blue lake, and brilliant red

Bronze yellow with a touch of transparent brown and blue lake

Shadow colors

Transparent brown with a touch of Prussian blue and blue lake

Blue lake with transparent brown and a touch of permanent violet

Afro–Caribbean skins: watercolor pencil

Base colors

Sienna brown with imperial violet

Sienna brown with deco pink

Light umber and yellow ochre

Shadow colors

Light umber and dark green

Light umber and imperial violet

TECHNIQUES

Asian skins: watercolor

Base colors

Green–gold and
permanent red

Green–gold and magenta

Green–gold and light red
with a touch of magenta
and a touch of
phthalo blue

Shadow colors

Phthalo blue and light red

Green–gold and magenta
with a touch of
Prussian blue

Asian skins: acrylic

Base colors

Yellow ochre with
touches of light green
and blue lake

Yellow ochre with a touch
of blue lake

Bronze yellow and
transparent brown

Shadow colors

Transparent brown with
a touch of blue lake

Bronze yellow with
a touch of Prussian blue
and transparent brown

Asian skins: watercolor pencil

Base colors

Deco pink and
yellow ochre

Yellow ochre and
sienna brown

Yellow ochre and peach

Shadow colors

Sienna brown

Light umber

Chapter 4

GALLERY

Over the following pages you'll find a selection of fantasy paintings by successful illustrators, in both traditional and digital media. These paintings feature the main themes of fantasy and will provide you with inspiration as you develop your own unique style.

the Women of Fantasy

When people think of high fantasy, it's often the heroines and villainesses they recall rather than the sword-wielding hero. The women of fantasy play a major role in the art of the genre. If you can handle these characters well, your success is probably assured.

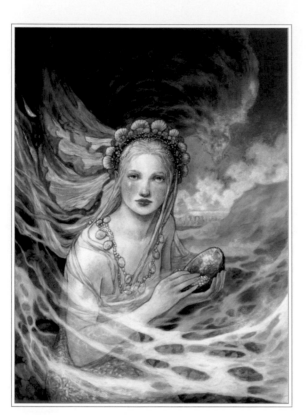

APHRODITE
by Rebecca Guay

Once more, the setting tells much of the story in *Aphrodite*, which depicts the Greek counterpart of the Roman love goddess Venus, who rose from a shell in the sea. The artist has, though, chosen to make the focus of attention Aphrodite's face, and particularly the eyes, in a superb use of portraiture to fantasticated effect.

PERSEPHONE
by Tom Kidd

The relationship of characters to their settings can be used to tell much of the story. Titled *Persephone*, this piece refers to the legend of the daughter of Zeus and Demeter who was abducted to the underworld by Hades as his bride. She was, however, allowed to return to this world in winter. This oil painting consciously creates various levels of visual depth.

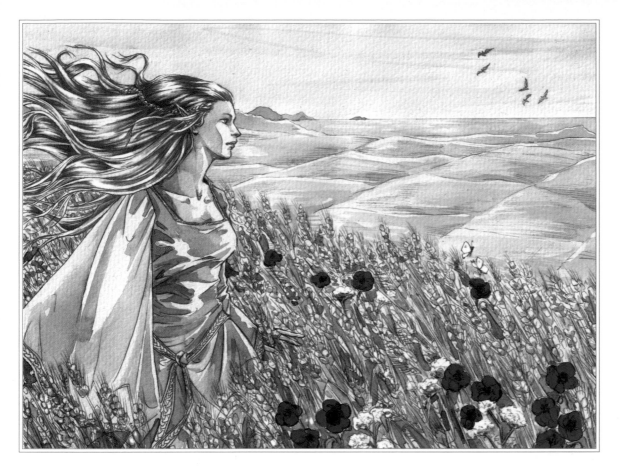

✍ FIELDS OF GOLD
by Jenny Dolfen

The success of fantasy paintings lies as much in mood as in the depiction of anything overtly fantasticated. *Fields of Gold* could be a real-life scene, but costume, character, surroundings, and especially the idealized billowing of the hair convey that this is fantasy.

✍ RAPUNZEL
by Larry MacDougall

This artist is fascinated by witches in fairy tales and has explored this theme many times in his work. In this piece he chose to illustrate the beginning of the story where Rapunzel has been taken by the witch rather than the usual scene of the witch climbing Rapunzel's hair. The physical contrasts between the witch and Rapunzel are conveyed with great success.

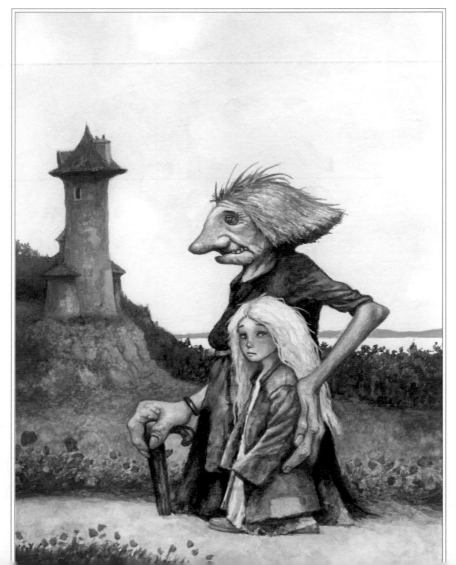

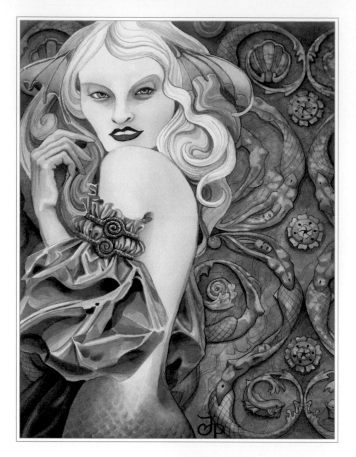

UNDINE
by Jessica Palmer

Fantasy art has room for many styles, not just the near-photographic realism that was the predominant fashion in the recent past. With a sort of Art Deco sensibility, *Undine* conjures up a fantasticated version of feminine allure using decorative elements that seem to equate the female form with the serpent: Truly a femme fatale? The undines were water spirits, as expressed by the graphic design rather than the detail of the background, and often they were indeed fatales.

GALLERY

ANGEL'S ROCK
by Uwe Jarling

If poorly used, digital techniques can generate a cold precision that may be the antithesis of the mood you want to create. Sensitively used, however, as here in *Angel's Rock*, where they give precision to details like the wing feathers yet generate impressionistic depth in the background, they can be a powerful addition to your armory.

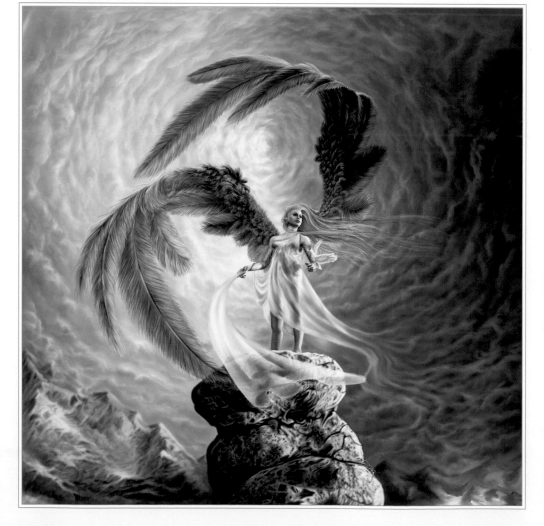

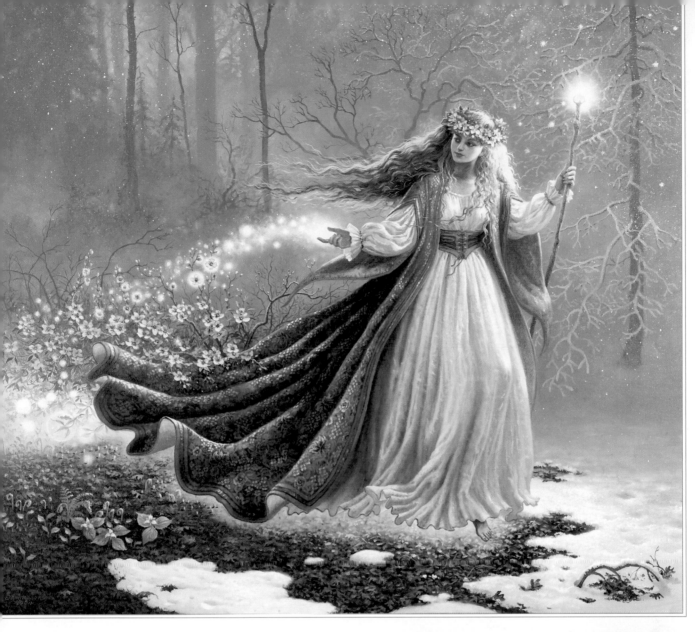

THE
WOMEN
OF FANTASY

✥ SPRING

by Ruth Sanderson

Attention to detail can generate a fantasy ambience all its own, especially when juxtaposed with special effects. While digital techniques are perfectly designed for this, they're far from essential: This painting, *Spring*, showing the eponymous goddess sowing life amid the last vestiges of winter, was done in oils on masonite.

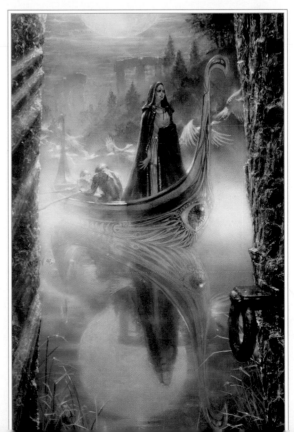

✥ MISTS OF AVALON

by Doug Beekman

Mood is everything in this cover illustration for Marion Zimmer Bradley's feminist Arthurian novel *The Mists of Avalon*. The mood is captured not just by the pervasive haziness (especially in the reflection), the background architectural details, and the huge moon, but by the preponderance of blues. Note too the claustrophobic framing of the scene by the foreground details.

fantasy's Leading Men

Depicting fantasy heroes (and villains) is a task that goes far beyond mere portraiture. The heroes of high fantasy are products of a fantasticated world, yet at the same time must usually seem to the viewer to be firmly rooted in reality. Capturing this dual nature is only the beginning . . .

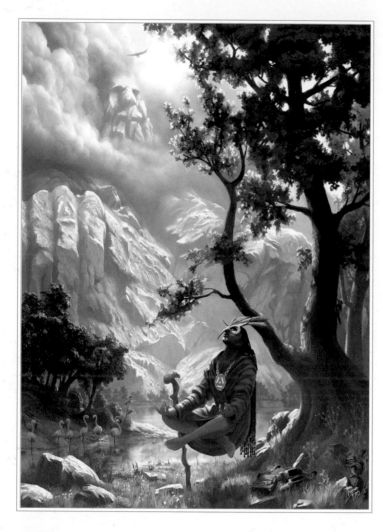

KNIGHTS FIGHTING
by Ruth Sanderson

The depiction of characters can tell us who we should be cheering for: No prizes for guessing that the fallen, lightly armored figure in *Knights Fighting* is our hero, while the fully armored, stocky, standing figure, with an evil glint shining from his sword, is the villain . . . at least for now. Note the realism of weaponry and costume.

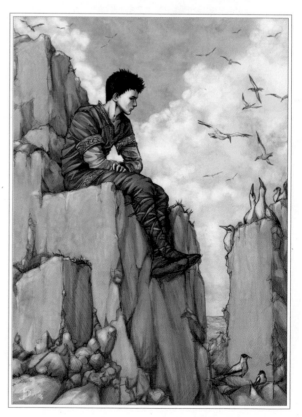

FAITH
by Simon Dominic Brewer

Matters of the spirit are as important to fantasy heroes as are weaponry and fighting skills. In the digital painting *Faith*, the masked figure, head thrown back to look beyond the natural marvels of this world, is buoyed above the ground by the power of his mind, or his faith. The distant mountaintop seems to be looking down on him like an elderly spiritual mentor.

ATOP TWR ADERYN
by Jenny Dolfen

The surroundings can create the mood the viewer ascribes to the central figure. In *Atop Twr Aderyn* the muted (though not dark) colors of the rocks and the exuberance of the seabirds emphasize the reflective expression of the medievally costumed central figure.

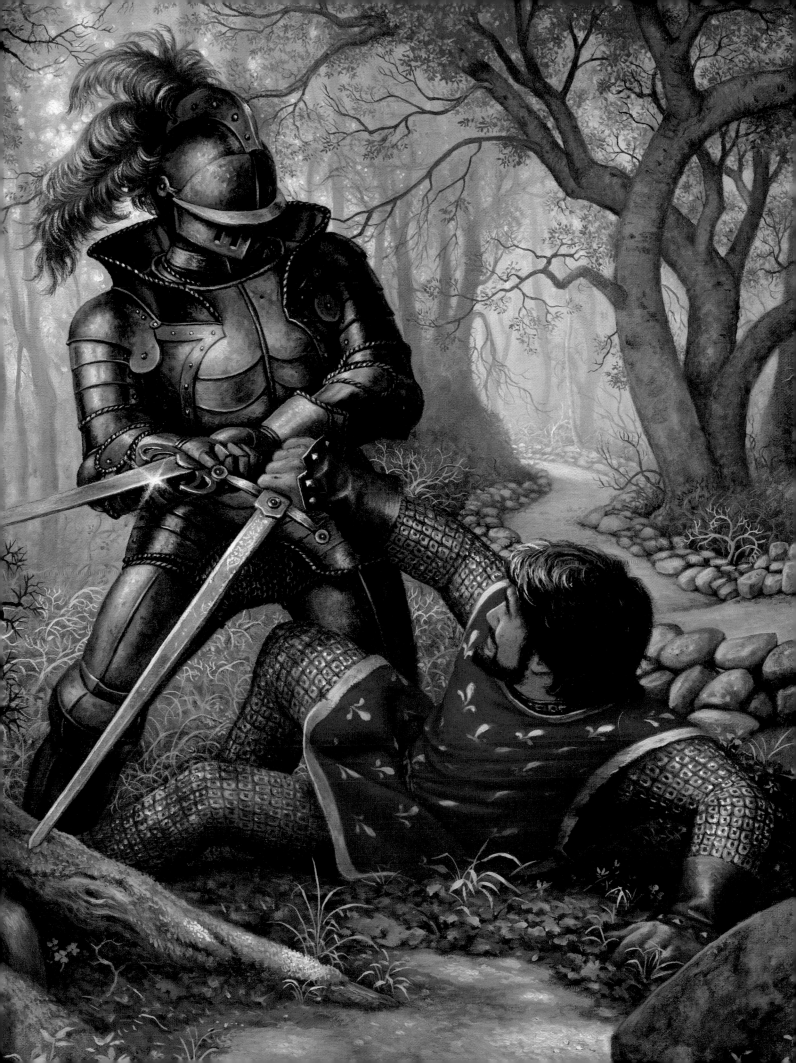

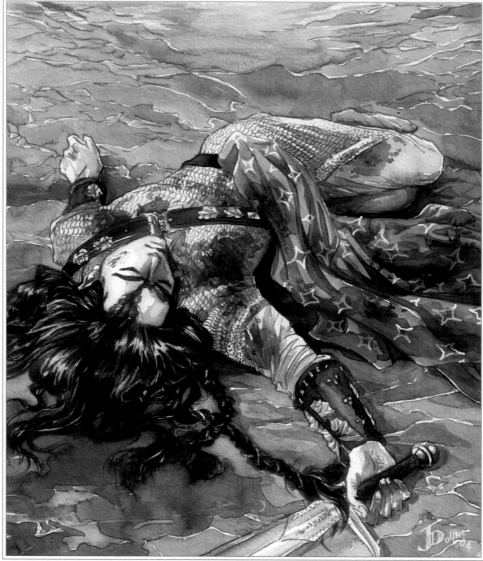

 IMRAHIL TENDS TO HIS NEPHEW
by Anke Eissmann
Stylization can convey more than photographic realism. In the watercolor *Imrahil Tends to His Nephew*, done as an illustration for J.R.R. Tolkien's *The Lord of the Rings*, the nobility of the fallen hero and of those helping him is conveyed by a stylistic reference back to medieval art, and hence to the Age of Chivalry.

NIRNAETH ANOEDIAD
by Jenny Dolfen
Perspective can help tell your story. The heroes of high fantasy triumph in the end, but almost all of them are imbued with the spirit of tragedy, and we're always aware they may fall before fulfilling their quests. The perspective conveys almost as much as anything else in *Nirnaeth Anoediad*. Here digital techniques were used to color a monochrome watercolor original.

PTAH HOTEP
by Jana Šouflová
In illustration, your composition must largely be determined by the use to which the picture will be put. *Ptah Hotep* was done as the cover for a fantasy novel, so the main image is on the right—i.e., on the book's front cover. Space must be reserved there for the title lettering, with plenty of space also in the picture's left half for blurb, barcode, etc. Even so, the overall composition remains excellent in this very skilled piece.

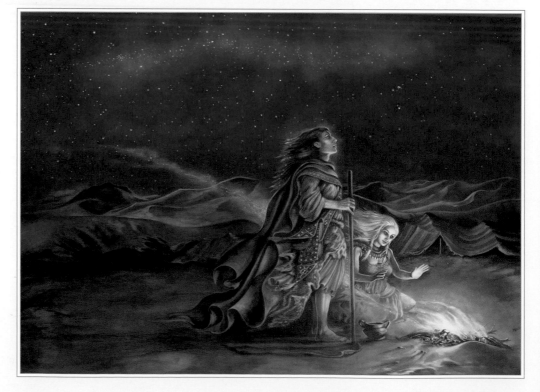

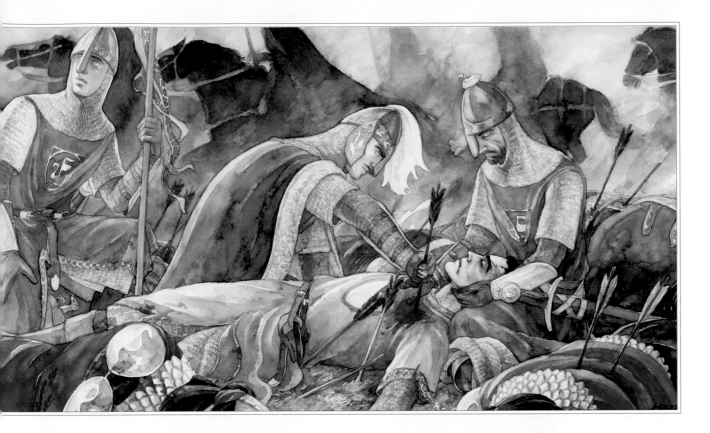

FANTASY'S
LEADING MEN

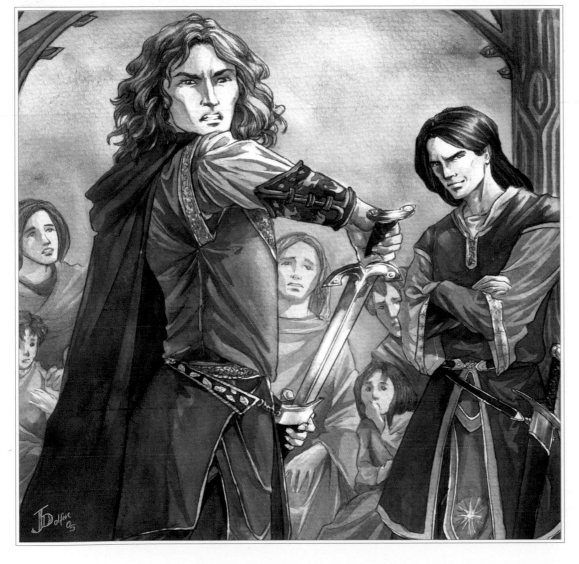

❧ CELEGORM AND CURUFIN
by Jenny Dolfen

Despite Conan the Barbarian, the traditional hero of much high fantasy, while ever willing to fight and skilled in doing so, at the same time possesses great sensitivity. Both aspects are captured here in *Celegorm and Curufin*. This began as a grayscale watercolor, the earth colors being added digitally: usually the hero is depicted as attuned to the earth and nature.

Fairy Folk

 Fairyland is really where it all began for the Western fantasy tradition, in eras when the fairies were sinister and not to be trusted. The Victorians introduced us to the gauzy-winged little pranksters we know so well today. Try your hand at both styles.

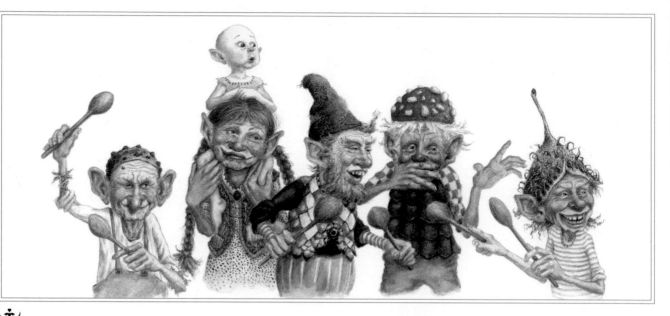

 FROM FAIRY WINGS
by Lauren Mills
Successful character design of nonhuman creatures often depends, paradoxically, on imbuing them with markedly human attributes. Each of the faces in this array of fairy folk, done as a book illustration (from *Fairy Wings*, by the artist and Dennis Nolan), is full of character and life because it caricatures a human expression.

THE BOOK OF LITTLE FOLK
by Lauren Mills
Even though they're supernatural, fairies are more in touch with the natural world than we are, and should normally be depicted thus. Done as a cover for a book called *The Book of Little Folk*, this watercolor gives the two fairy minstrels insectile qualities and form.

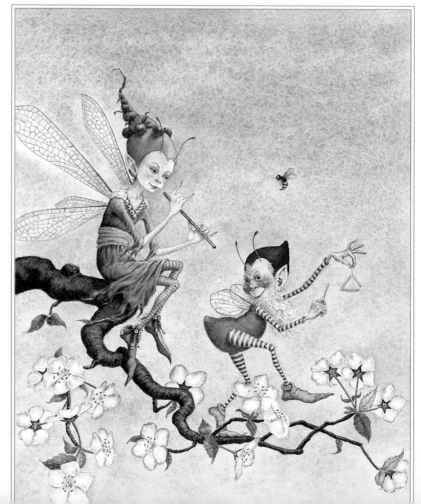

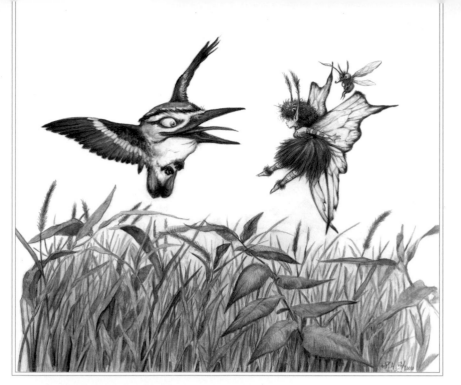

PIPSQUEEK & A PESKY KINGLET
by Patricia Ann Lewis-MacDougall

There's plenty of room for the artist to explore humor when working with the Victorian-style Fairyland. Here the humor derives from scale: We're suddenly reminded, by the confrontation with the bird, how small the feisty heroine truly is.

FAIRY FOLK

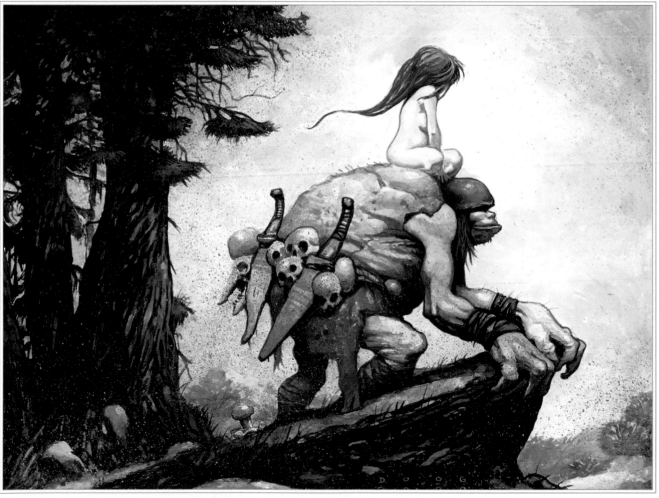

SCOUT
by Larry MacDougall

The denizens of Fairyland are not just the petite, winged, ethereal creatures popularized in the Victorian era. In keeping with their earth-attunement, they can instead be solid and chunky. In this painting, *Scout*, the relative statures of the characters, and their placement, tells the story wonderfully.

fantasy Architecture

There's a school of real-life architecture called fantasy architecture, whose practitioners realize strange dreams in the form of genuine buildings. Those artists are constrained by the physical properties of the materials they use. You need not be.

TWILIGHT
by Jessica Palmer

Fantasy architecture can be realistic architecture depicted unusually. In *Twilight*, the boats on the water impart to the buildings and viaduct a tremendous scale, while the overall yellowness of the lighting gives the impression that we're being offered a glimpse into a world where everything's a little bit . . . different.

WHITTREDGE FOREST
by Tom Kidd

Conversely, fantasy architectures can be as improbable as you want to make them. For *Whittredge Forest*, the artist used the texture of the paint, dry brush techniques, and tapping of the brush to achieve the realism of the tree bark. As a result of this effort, the lofty domicile, however implausible in real life, appears perfectly consonant with its context.

✿ THE JACKAL OF NAR
by Doug Beekman

Fantasy cities can be places of great splendor. Perspective is used to fine effect in the cover for John Marco's novel, *The Jackal of Nar*, to create depth, thereby giving the city a scale and magnificence implausible for the pseudomedieval setting, yet perfectly feasible as a visual image, thanks to the skill of the artist.

FANTASY
ARCHITECTURE

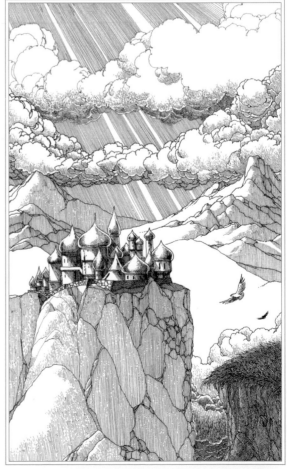

✿ CITY OF EAGLES
by Bob Hobbs

There is no need to restrict your architecture to the Western tradition. There's considerable strangeness in *City of Eagles* because of the city's location high on the crags of a remote mountain region, but it's added to by the onion domes. What nature of people live here, and why should they choose to isolate themselves like this? And against what manner of foe do those city walls defend?

Creatures' Features

Humans are only one element of the worlds created by high fantasists. There are plenty of other creatures there as well; often they are brighter, stronger, and better than the humans, but equally often they are evil grotesques. The joy of painting fantasy creatures comes in learning to let character shine through an alien mask.

112

GALLERY

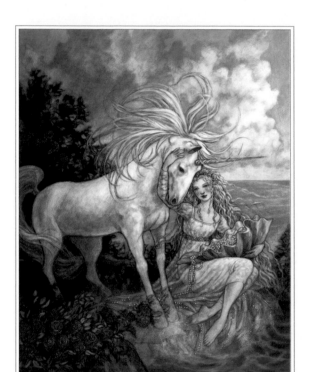

 CRICKET
by Rebecca Guay

The unicorn has strong romantic connotations, and unicorns should almost always be depicted accordingly. They're also, along with dragons and mermaids, the perennially most popular fantasy animals of all. Coloring, style, and the association with an Aphroditelike figure contribute to the lushly romantic atmosphere of *Cricket*.

 CHIMES OF YAMARA
by Steve Roberts

In portraying the power of dragons, don't be afraid to play fast and loose with scale. *Chimes of Yamara* is a tremendously exciting painting because of the obvious hugeness of the dragon and because of its building-top perch; it matters not at all that the dragon's riders might have to bend over double to walk around in the building beneath them!

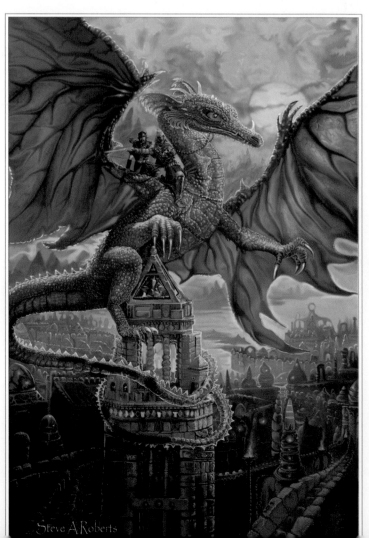

THE LAST UNICORN
by Doug Beekman

A further attribute of unicorns is solitude, a quality stressed by Peter S. Beagle in his classic fantasy novel *The Last Unicorn*. The romanticism of the sylvan setting in this cover image is highlighted by the judicious use of special effects: The unicorn seems almost spectral, as if living in another world as much as in ours.

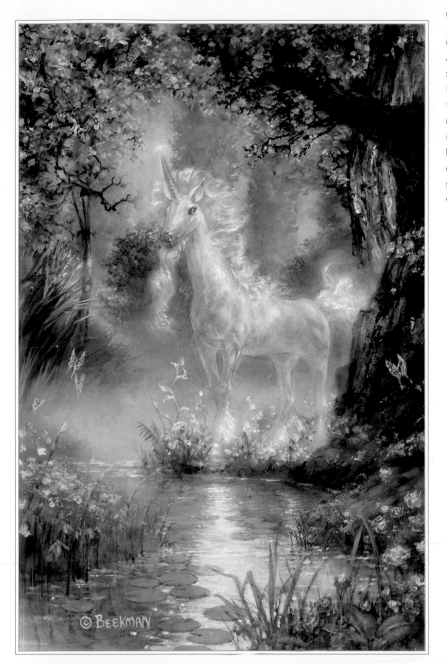

CREATURES'
FEATURES

JADE DRAGON
by Jana Šouflová

The appeal of dragons lies largely in their power and dynamism. In the painting *Jade Dragon* it's the dynamism that's emphasized, with a tremendous sense of motion being generated through the creature's interaction with the natural environment. The coloration enhances the naturalness of the setting: The painting was done on green paper using entirely shades of green, except for a little indigo.

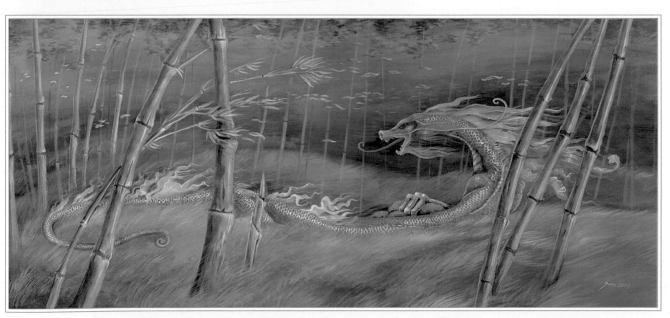

GALLERY

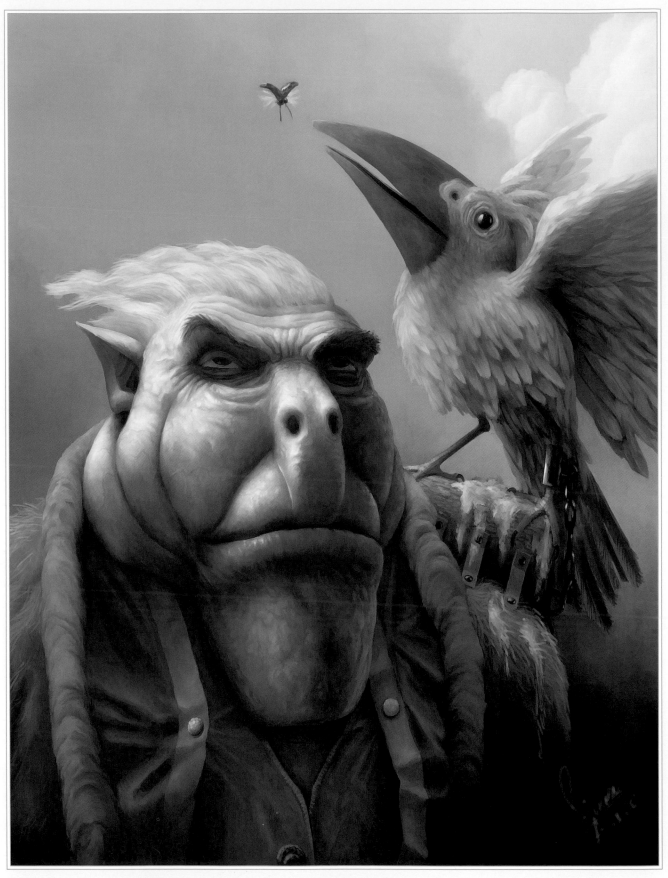

 TIMOTHY
by Simon Dominic Brewer

Inventing your own fantasy creatures is as much fun as playing with the well-known icons of the mythological bestiary. The central character of the digital image *Timothy* has distinctly human attributes, yet these are morphed to the extent that we know he cannot be human. The alien affect is enhanced by the near naturalism of the bird and the insect.

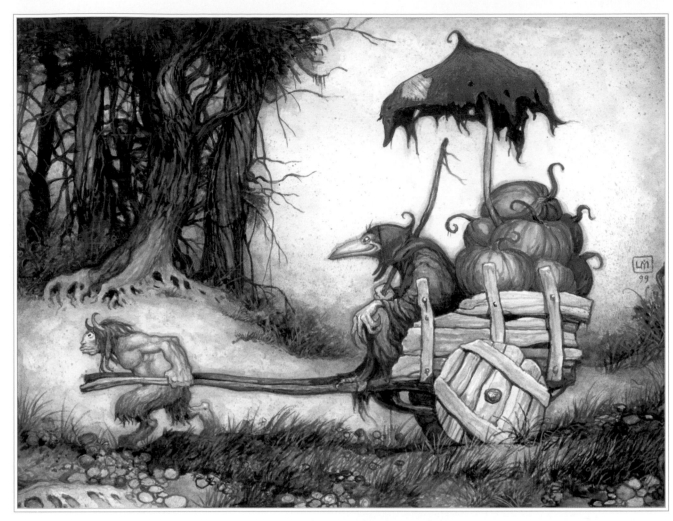

❧ PUMPKIN DEALER
by Larry MacDougall

Juxtaposing features of different animals in a single individual can make for a powerful fantasy sense. The rider in *Pumpkin Dealer* mixes features of bird and human (note the feet), but the figure pulling the cart is stranger still, with attributes of satyr (including horns), ape, and human. A great example of creating narrative through characters.

❧ FROM FAIRY WINGS
by Dennis Nolan

Caricature, if handled correctly, can elicit that fantasticating sense of strangeness rather than humor. In another context the figure in this watercolor illustration from the children's book *Fairy Wings* might evoke amusement, with his hugely exaggerated nose, teeth, and ears. Here, though, he seems frighteningly unpredictable.

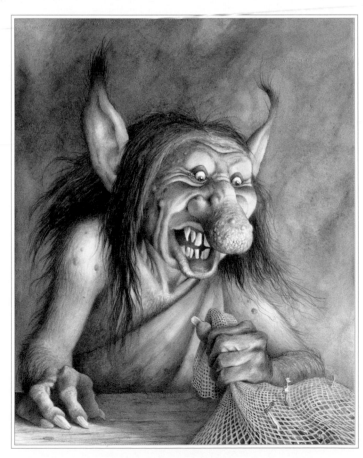

Fantasmagoria

What fantasy is really all about is imagination. Without imagination there can be no fantasy. Imagination is really the most important piece of equipment the fantasy artist possesses, and the most versatile technique. All the rest will follow if you dare to imagine.

FLY AWAY HOME
by Jessica Palmer

Giving your audience the unexpected is a large part of fantasy art. This painting's title, *Fly Away Home*, is punningly reified as one end of the mobile home gradually breaks down into a flock of birds. It's more than a clever visual trick. The narrative effect comes from the question posed to the viewer: At some time in the past, did a flock of birds become the mobile home?

ARBOREAL PACHYDERMS
by Tom Kidd

If two things don't normally go together, try putting them together. The fantasy dislocation in *Arboreal Pachyderms* is a simple consequence of the unexpectedness of finding tree-dwelling elephants, followed by the recognition of quite how big this tree must be! The dislocating effect is enhanced by the use of watercolors, so that plenty is left to the viewer's imagination.

A WIZARD CHAMBER
by Bob Hobbs

Fantasy can spring from appropriately linking disparate elements. The objects littering *A Wizard Chamber* could each, on their own, be perfectly mundane; put them together in the same scene, though, and we know at once they're of magical import—an effect enhanced by the "Old Masters" treatment achieved in what is actually a digitally created image.

ARE YOU A FRIEND?
by Uwe Jarling

Atmosphere and mood can tell a story as effectively as any overtly fantasticated elements of the image. The humanlike creature emerging from the tree in *Are You a Friend?* would be striking enough in itself, but it's the dark, brooding surroundings and the skilled use of an unidentifiable light source on the central scene that really make this digital image special.

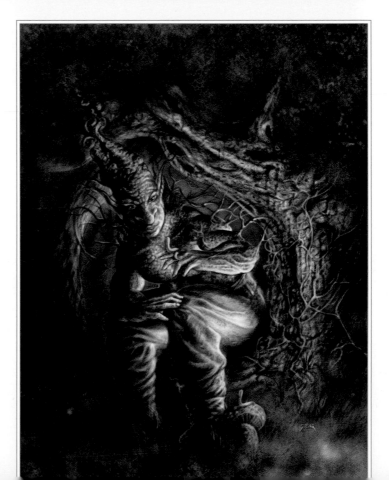

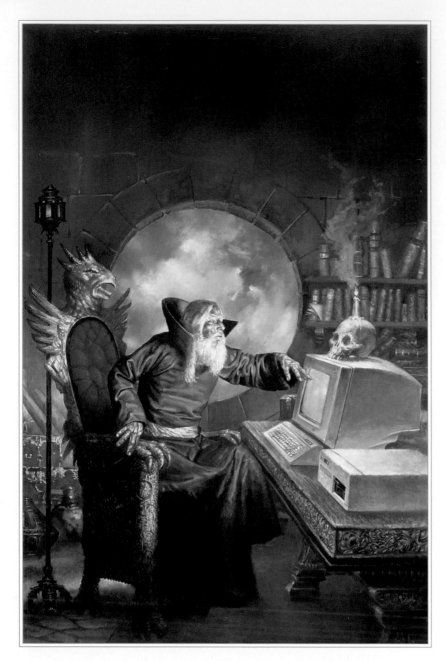

SPELL CHECK
by Doug Beekman

Fantasy art can use symbols drawn from modern technology as effectively as those from the pseudomedieval world of much high fantasy. Written fantasy plays across all periods of history, up to and including the future, so there's no reason your art can't do the same. In this picture the artist has made a joking pun with his title, *Spell Check*, and brought it to life as a great fantasy-inspiring image.

THE FOREST OF THE DEAD
by Bob Hobbs

The strongest fantasy of all is in the mind of the viewer. The title *The Forest of the Dead* gives a clue to this picture's fantasticating purpose, yet the artist has restricted his media to pen and inks, using painstaking crosshatching and other linework to give us a stark and superficially simple image. It may be a long while before we notice the size of that tree trunk in the background . . .

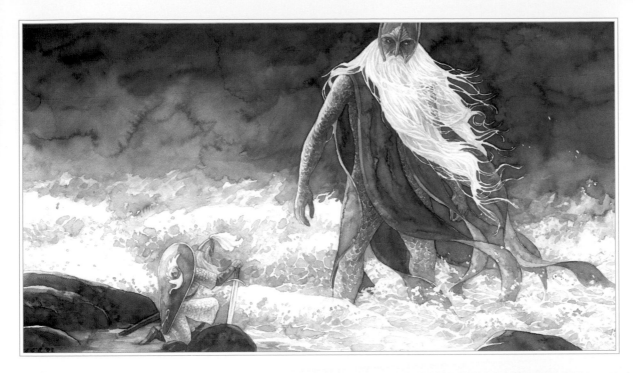

✒ THE LORD OF THE WATERS
by Anke Eissmann

Limiting your color range can be as effective in telling a fantasy story as using every paint on your palette. In *The Lord of the Waters* (done to illustrate a Tolkien tale), the predominant yet understated watercolor grays and greens serve to enhance our sense that the main figure is both fantastic and intimately connected to the natural world. Quasi-paradoxically, the stylization emphasizes this effect.

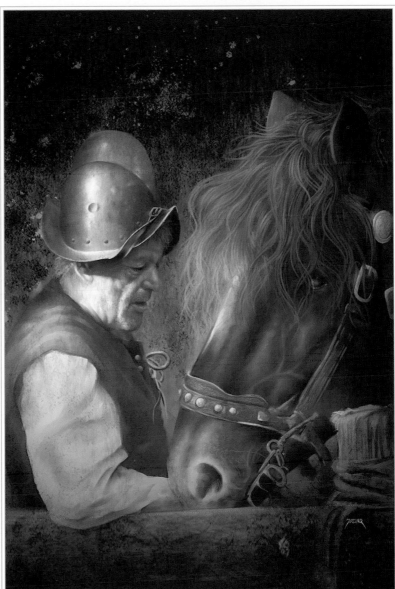

✒ THE OLD MAN
AND HIS TRUSTY FRIEND
by Uwe Jarling

Sometimes a fantasy illustration doesn't need to contain any fantastication at all! In *The Old Man and His Trusty Friend*, the old man's costume hints at a fantasy context, but this could as well be an historical portrait. Amusingly, the painterly Rembrandtish effect is created not by brushwork but by using digital techniques.

Professional Development

Illustrators are rarely instinctively good at self-promotion, being happier to get on with the work they love to do than to sell it and themselves. Warnings about not getting work unless you sell yourself can be balanced by considering that, no matter how well you market yourself, it won't be effective if your work is inferior.

For the best chance of success, consider a busy editor's or art director's perspective on judging potential illustrators. Illustration of all types is a highly competitive field. Each year, eager art graduates are unleashed, not to mention the number of talented, but untrained, people of all ages who wish to work in publishing. It is unreasonable to expect editors to have lots of free time to view unsolicited samples, dummies, and portfolios. It is even less likely that a face-to-face portfolio presentation can be scheduled in busy publishing companies. It is also worth remembering that levels of visual literacy among publishing employees who may be the first point of contact do vary enormously. It often comes as a surprise to graduates, after three years of critical dialog within an art school environment, to face minimal (or zero) feedback from potential commissioners. The fact that those sitting "in judgment" are, by and large, not art trained may also come as a shock, and it is as well to be prepared for the inevitable criticism that is aimed at transforming "art" into work with mass-market appeal.

Know your market
You must research the market. If you are serious about what you do, you will have a deep interest in the climate and trends. Although it is important to have a sense of what is contemporary, it is even more important not to be captive to it. At any time in the past, there have been books on the shelves by artists with long and glorious careers behind them, alongside books by young artists who may, or may not, have gone the distance.

Check out who is publishing what. Every publishing house has its own approach or leaning, and it is a waste of everyone's time to submit entirely inappropriate work to a particular publisher. Conversely, if you are able to demonstrate a thorough knowledge of the books published by a company that you have approached, it will impress and reassure everyone that you are serious.

Previous experience?
There is, of course, the "Catch 22" syndrome when publishers want to know if you have been published by another company before they decide to take a risk themselves. This is extremely common. A student returned from a meeting at a leading publishing house to discuss her new art roughs, and related how the entire atmosphere of the meeting changed when she casually mentioned that she had written, and illustrated, a published picture book. The responses to her ideas were instantly more positive and respectful. This is to be expected, so it is necessary to project professionalism in order to secure that all-important first commission.

In a busy and very competitive field, a personal introduction goes a long way. You may have an instructor who has contacts, and his or her recommendation may make a big difference. If you are creating your own illustration-based books, a well-presented dummy sent to an identified editor with an accompanying letter will get looked at. It is clear that having your own web site is an increasing necessity. If an art director or editor receives a postcard or flyer with your work on it, it is easy for them to tap into your web site to see more.

Professional approaches
If you present yourself in a professional manner, it is more likely that others will have confidence in you. For example, in book publishing, getting along well with the people you are working with is particularly important. After all, unlike the world of the one-off editorial illustration, a 32-page book means a close working relationship between editor and artist for a considerable period of time. To get work, the designer or editor is going to want to be reassured that you are organized, reliable, and pleasant. These qualities will need to be projected from the outset.

Preparing your portfolio
A neat, well-presented portfolio of work is essential. It should be a manageable size.

No one is going to want a huge folder thrown on the desk. If your original artwork is large, you should get good-quality small-scale prints made. Don't put too much work in. You may have a dummy book to show if you are presenting an idea, and alongside that a couple of finished spreads.

Samples of general illustration work need not exceed eight sleeves (16 sides). Never put anything in the portfolio that you are not happy with, or are unsure about. The golden rule is to leave it out if you have any doubts. There is nothing worse from the publisher's point of view than being told, "Oh I really hate that one" or, "I don't work like that anymore."

When mailing out material, don't send original artwork. Always send copies. If you want the copies back, make sure you send a stamped, self-addressed envelope.

It is becoming more common to present samples of work as a digital file, but, for sheer impact, nothing matches seeing a well-presented portfolio. Even if you only use the traditional media of painting and drawing, keeping digital copies of your work is invaluable. An old-fashioned portfolio can go out to only one client at a time. Consequently, it is a good idea to keep a digital document of your portfolio at letter size to print out from your inkjet when you need it. This method also allows you to mix and match the images in your portfolio according to the needs of the client in question. This method can become expensive, so find a supplier on the Internet who can provide bulk paper and ink cartridges inexpensively. Make an extra effort to find papers that give quality reproduction but don't cost a fortune.

Promotional material

Printed postcards showing samples of your work can be produced quite inexpensively and will be most effective in keeping your work under the art director's eye.

If you care about your presentation, you will want your own letterhead. This may be a simple, sober, purely typographic design, or illustrated, and that will depend on your temperament and taste. This can be augmented by a "With compliments" slip and personalized invoice.

Web sites are important as a promotional tool, and you may want to set one up so you can direct people to view it at their leisure. Some publishers only want to view illustrators' work through web sites; others prefer sample material provided as hard copy, mailed to them with accompanying contact information.

Digital art format and presentation

Don't e-mail potential clients large files that will take a long time to download—it will probably annoy them. It is best to send a résumé first and an address for your web site if you have one. If you are sending a résumé by regular mail, it is usually OK to send some samples of your work.

Keep your résumé short. Most editors don't have time to read more than a page. Most e-mailed résumés go straight in the wastebasket. It is better to do some research and find the name of the appropriate person to send it to and then send it by regular mail.

Web sites

Many editors and publishers look for artists via their web sites, and it has become quite easy to build your own web site for showing your work. It's important to have a web site that works efficiently and can be found easily by search engines. For these reasons, it is worth consulting an experienced web designer who can navigate these issues. Keep in mind that potential clients will not be interested in dazzling animations and clever web site design. More often than not, they will want to see your work in the quickest,

simplest way possible, and be able to contact you easily if they are interested. The point is, don't get carried away.

Artists' agents

Many illustrators and authors choose to be represented and promoted by agents. Many choose not to. What are agents? Should you have one?

In reality, the choice may not be yours, as it should not be assumed an agent will take you on. They need to be sure that they can get you commissions, and thereby earn money. Essentially, an agent represents a number of artists (and, in the case of literary agents, authors), and endeavors to secure commissions for them. The agent takes a percentage of the overall fee from the commissioner for providing this service.

Artists' agents, as the name suggests, deal with commissioned art. They represent a number of illustrators (the number varies greatly from one agency to another), and will compete in the market place on behalf of their artists. They will be looking for work in the worlds of advertising, design, magazines, and book publishing. Agents will typically charge between 25 and 33 percent of the commission fee for their work. Generally speaking, the agency will do its best to promote the work of an illustrator and to negotiate as high a fee as possible —it is as much in their interest as it is in the illustrators'.

Artists may not be natural businesspeople, and it takes a great deal of courage and confidence to put a realistic value on your own

work, and to hold out for a higher figure. It is all too easy to accept what might be a derisory fee, especially when you are just starting out. So a third party, with good business sense and without the handicap of being the creator of the work, is likely to be able to negotiate a fee that is high enough to compensate for the percentage that is lost to him or her.

Contractual agreements between artists and agents vary. Some artists' agents operate without contracts, working on the basis of trust. It is important that the artist and agent agree on whether the agent should take a cut on all the artist's commissions or on only certain areas of work. Good communication is essential if trust is to be maintained. Some commissioners of illustrations prefer not to deal with agents, feeling that they come between the designer or editor and the artist. There will always be a full range of opinions on the pros and cons of agents, depending on personal perspectives and experience. At one extreme they are the stereotypical sharks, and at the other they may prove to be guardian angels. Many author/illustrators have very close and supportive relationships with their agents and some will cite their contributions as having a major positive influence on the development of their careers, professionally and artistically.

You will need to establish yourself before an agent will agree to take you on (although some are good talent spotters and regular visitors to graduation shows). This will give you a chance to get to know the business firsthand. To be proactive in securing yourself an agent, there are a host of web sites to be sourced via search engines, although a recommendation is the route of choice.

Laws of copyright

Ideas themselves cannot be copyrighted, but how you express your ideas can be. As soon as you draw, write, or compose something in some tangible form, the idea in its tangible form is copyrighted, and you are the holder. Although you do not need to register your copyright to have it protected, no action for infringement of copyright can be undertaken unless the copyright of a work is registered. So, you can send your work to an editor for consideration without registering the copyright, and then have the publisher acknowledge the copyright in your name when the book is published.

When a work is published, a copyright notice should appear in all copies publicly distributed. It must include either the symbol or the word "copyright," the year of publication, and the name of the copyright owner. Within three months of publication of such work, the copyright owner, or the owner of the exclusive right of publication, must deposit within the Copyright Office two complete copies of the work for the use of the Library of Congress. Publication without a notice, or with an incorrect notice, will not automatically invalidate the copyright or affect the ownership. However, any error or omission should be corrected as soon as possible to prevent the eventual loss of protection.

Artwork for reproduction

When creating illustrations for reproduction, there are key things to remember about the presentation of artwork. Most original artwork is laser scanned on a cylindrical drum. This means your image has to be taped down onto a drum with the image facing outward, so you need to leave white space (about 2 inches/5 cm) around the edge of the image.

Full bleed is the term used when an image in a book goes right to the edge of the paper. When preparing your original, be sure you continue the image beyond the actual size of the page, and provide trim marks to show the edge of the page. If you choose to work larger than the actual reproduction size, make sure that all your originals are produced proportionally to the same degree of enlargement, that is half-up or quarter-up in size.

If you have produced your illustration digitally you will need to prepare it for submission as a jpeg or tiff that can be e-mailed or provided on disk. By either method, the document will need to be at least 300 dpi (dots per inch). Always check with the art editor first. You may choose to provide a printout for the reproduction house to be able to match color accurately.

When delivering artwork, label the work clearly on the back or on a protective overlay:

1 Title of book and publisher
2 Chapter or page reference
3 The size or proportion for reproduction—for example, s/s (same size) or half-up
4 Your name and contact information

PROFESSIONAL
DEVELOPMENT

Be sure the artwork is securely packaged with cardboard, and if it is not to be delivered by hand, use a courier or mail service that will insure and record delivery.

You can be the best artist in the world but it won't mean a thing if you are unreliable. Most clients would rather use a second-rate artist they know they can rely on rather than have to work around a genius who makes their life even more difficult than it already is. There are many artists who miss deadlines, and little by little the word gets around.

It is vitally important to return all calls from clients as soon as possible and keep them up to date on progress, particularly if there have been any changes to your artwork or schedule.

Publishing

Most artwork for print needs to be sized to 300 dpi (dots per inch) and saved in CMYK format, which can use a lot of memory and slow your process down. It's possible to work in RGB, which keeps the file size smaller, and then convert to CMYK at the end. This is easy to do in Photoshop. Keep in mind that if the printed image must be 300 dpi at the size it will be printed, you can reduce your source images to the final size before working on them so that the files are smaller and therefore quicker to work on.

Delivering work by e-mail

Any artwork that needs to be seen only on the computer screen, and not printed out, can be reduced to 72 dpi. If you are working on images for use only on the Internet,

you can work at 72 dpi. If you are working on an image for print at 300 dpi but need to e-mail it to your client for approval, it is important to make a 72 dpi copy so that it goes down the phone line as quickly as possible. You can also save it as a "jpeg" file, which is smaller than a tiff. It only needs to be about 400 to 500 pixels across for use on a computer screen, so you can cut it down that way as well. After you've done this, use the "Save for web" command in Photoshop's "File" pull-down menu to make another jpeg copy, which is compressed even more. Now you can attach the file to an e-mail and send it to clients without clogging up their system unnecessarily.

Pdfs

Pdf is a format for compressing entire documents of words and pictures for sending down the phone line. You can turn your documents into a pdf using Adobe Acrobat. This is a fairly expensive package but it is becoming an industry standard because recent developments in pdf mean that it is now possible to send a compressed document directly to the printer. If you are working on an illustration, comic, or book, this means you will be able to send your final print-ready artwork down the phone line, which will revolutionize the way artists work in conjunction with publishers and printers. It means you will never have to leave the house and can have a successful career as an artist while living halfway up a mountain in Alaska. Many publishers will be able to accept copies of your portfolio this way as well.

Data storage

The two main choices for data storage are CDs and external hard drives. Back up all your work on an external hard drive as you go, then regularly burn all new material onto CDs. Keep the CDs in a separate location from the computer and external hard drive in case of fire, theft, or flood. It's important to take the time to do this, and you need to factor it into your schedule. Losing work is common and it can affect your chances of future employment if you let a client down. It is worth finding a supplier on the Internet who can provide bulk CDs in boxes of 50 to 100 or more. Buying data storage in this way can save you a fortune.

123

PROFESSIONAL
DEVELOPMENT

Resources

Recommended Reading

I didn't learn to draw or paint the way I do from books or art schools. I learned by looking. By constantly looking at other artists' work, whether on the walls of museums or gallerys or in the many books published of their work, I became inspired to attempt what seemed impossible.

The following list of books is by no means complete or definitive but it will provide you with a good selection of titles to get started with!

Bridgman, George B.
Bridgman's Life Drawings
(Dover Publications, 1971)

Cowan, Finlay
Painting Fantasy Figures
(Barron's, 2003)

Evans, Peter
The Fantasy Figure Artist's Reference File
(Barron's, 2006)

Fabry, Glen
Anatomy for Fantasy Artists
(Barron's, 2005)

Froud, Brian
Good Faeries, Bad Faeries
(Simon & Schuster, 1998)

Froud, Brian and Berk, Ari
Goblins!
(Harry N. Abrams, 2004)

Froud, Brian and Lee, Alan
Faeries
(Harry N. Abrams, 1995)

Gilbert, Alma
Maxfield Parrish: The Masterworks
(Ten Speed Press, 2001)

Jennings, Kate F.
N. C. Wyeth (American Art Series)
(J.G. Press, 2003)

Johnston, Ollie and Thomas, Frank
The Illusion of Life: Disney Animation
(Disney Editions, 1995)

Ludwig, Coy
Maxfield Parrish
(Schiffer Publishing, 1997)

Pyle, Howard
The Book of Pirates
(Dover Publications, 2000)

Pyle, Howard and Menges, Jeff A.
Pirates, Patriots, and Princesses:
The Art of Howard Pyle
(Dover Publications, 2006)

Rackham, Arthur
Grimm Fairy Tales
(Trafalgar Square Publishing, 1982)

Riché, David, and Franklin, Anna
Watercolor Fairies
(Watson Guptill, 2004)

Walker, Kevin
Drawing and Painting Fantasy Beasts
(Barron's, 2005)

Artists' web sites

These are the web sites of the artists who appear in the book:

Doug Beekman
fantasyart@svcable.net

Simon Dominic Brewer
www.painterly.co.uk

Jenny Dolfen
www.goldseven.de

Anke Eissmann
www.anke.edoras-art.de

Rebecca Guay
www.rebeccaguay.com

Bob Hobbs
www.moordragon.com

Uwe Jarling
www.jarling-arts.com

Tom Kidd
www.spellcaster.cm/tomkidd

Pat Ann Lewis-MacDougall
http://home.cogeco.ca/~underhillstudio/

Gary Lippincott
www.garylippincott.com

Larry McDougall
http://home.cogeco.ca/~underhillstudio/

Lauren Mills
www.rmichelson.com

Denis Nolan
www.rmichelson.com

Jessica Palmer
www.frogbells.com

Steve Roberts
www.fantasy-graphic.com

Ruth Sanderson
www.ruthsanderson.com

Jana Šouflovà
www.maffet.cz

Useful web sites

The Arthur Rackham Society
www.angelfire.com/ar/ArthurRackhamSociety

The Association of Science Fiction
and Fantasy Artists
www.asfa-art.org

The Magazine of Fantasy and Science Fiction
www.sfsite.com

Realms of Fantasy Magazine
www.rofmagazine.com

Science Fiction Book Club
www.sfbc.com

The Tolkien Society
www.tolkiensociety.org

Index

A

abstract sketches 22–23

acrylic paints 15, 90

agents 121–122

anatomy 58–59

 abbreviated 59, 60–61

 animal 59, 64

 to simplify 56

animal characters 27, 62–65;

 see also beasts

 anatomy 59, 64

 crossed species 35, 63–64, 115

 interaction with 48

 size 64

architecture 110–111

Arthurian legends 24, 26, 30, 32

artwork: digital 16–17

 past 30, 31, 32

B

beasts 24, 62–65;

 see also animal characters

 gallery 112–115

body language 42–43

body shapes 59

box, to draw 70

bracelet shading 77

brushes 13

C

characters: features 34–39

 interaction 48–49

 personality 42–43, 59

 stature 40–41

cloth, to study 68

color: to blend 89

 to build up 86–87

color mixing 80, 92–93

overlays 83, 87

 surface 82–83

 wet-in-wet 83, 89, 90, 91

colored pencils 11

colors, to keep separate 83

composition 23, 74

computers 16

conté crayons 76, 77

contracts 122

copyright 122

costumes 42, 68–69

crosshatching 77, 78, 79

cube, to draw 70

D

data storage 123

depth 70–71

design, balanced 23

design programs 17

digital artwork 16–17

Doré, Gustave 31

dragons 24, 112, 113

drawing media 11

dwarves 40

E

ears, to draw 39

enlarging a drawing 75

erasers 11

eyes, to draw 38, 39

F

facial expression 42–43

facial features:

 to exaggerate 34–37, 115

 to simplify 54–55

fairies 25, 40

 gallery 108–109

fantasy: historical 26

 traditional 24–25

fees 121–122

feet, to draw 58

figure drawing 53, 56–57

 use of perspective in 71

file compression 123

folktales 30

forms and edges 78, 79

foundation drawing 66–67

G

geometric shapes 52–57

giants 41

gnomes 34, 40

gouache 15

granulation 90, 91

graphics tablet 16

H

hands, to draw 59

hatching 77, 78, 79

heads, to draw 53, 54–55

heroes 25

 gallery 104–107

highlights 84–85

historical references 32

horizon line 70

Hunt, William Holman 31

I

Illustrator 17

imagination 30, 116–119

ink lines 78

inks 12, 78

inspiration 30–33

interiors 71

127

 # Credits

Author Acknowledgments

The author would like to thank all of the artists who sent in artwork for inclusion in the book. A very big thank you goes to Paul Barnett for his contribution. Thanks also to the artists Alan Lee and Brian Froud—they are the reason why I paint, what I paint, and how I paint. Other credits go to my family and friends who have kept me "on track" with my career.

Quarto would like to thank the contributing artists for kindly submitting work for inclusion in this book. All artists are acknowledged beside their work.

Quarto would also like to acknowledge the following:

Key = a above, b below, l left, r right

p31r Tyne & Wear Museums www.twmuseums.org.uk
p31b "Perrault's Fairy Tales" Illustrated by Gustave Doré, Dover Publications Inc.
p33l "Beech in the Mist" Luca Fantoni & Danilo Porta
p83br "Imrahil Tends to His Nephew" Anke Eissmann
p108a, p108b, 115b Photographed by Stephen Petegorsky